IMAGES
of Amer

D1361075

GERMAN
CHICAGO
REVISITED

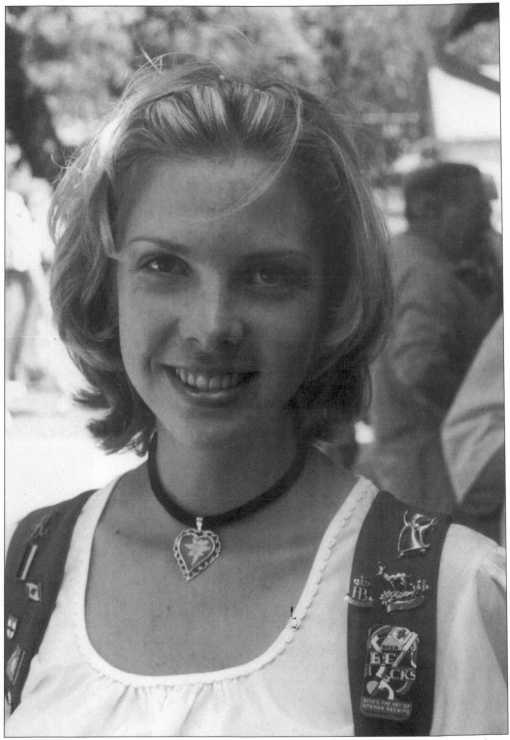

KARINA HOPP. She was photographed at the American Aid Society of German Descendants picnic grounds in Lake Villa, IL. (Photograph courtesy of Raymond Lohne.)

IMAGES
of America

GERMAN
CHICAGO
REVISITED

Raymond Lohne

ARCADIA

First printed in 2001.

Published by Arcadia Publishing,
an imprint of Tempus Publishing, Inc.
3047 N. Lincoln Ave., Suite 410
Chicago, IL 60657

Printed in Great Britain.

Library of Congress Catalog Card Number: 2001088174

For all general information contact Arcadia Publishing at:
Telephone 843-853-2070
Fax 843-853-0044
E-Mail sales@arcadiapublishing.com

For customer service and orders:
Toll-Free 1-888-313-2665

Visit us on the internet at http://www.arcadiapublishing.com

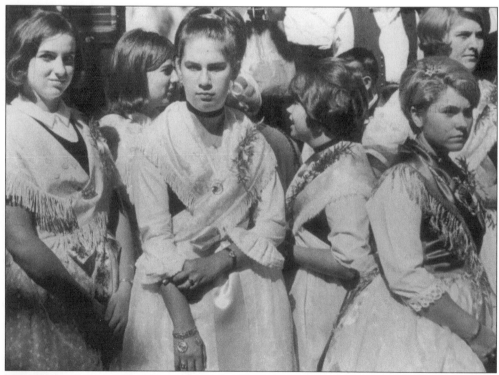

NEW YORK, STEUBEN DAY PARADE, 1969. These young Danube Swabian women graced the cover of my first *German Chicago* book with Arcadia, ironically enough. Since the original picture had to be cropped for that cover, I wanted to present it now as I first received it. (Photograph courtesy of Eva Mayer, New York Donauschwaben.)

CONTENTS

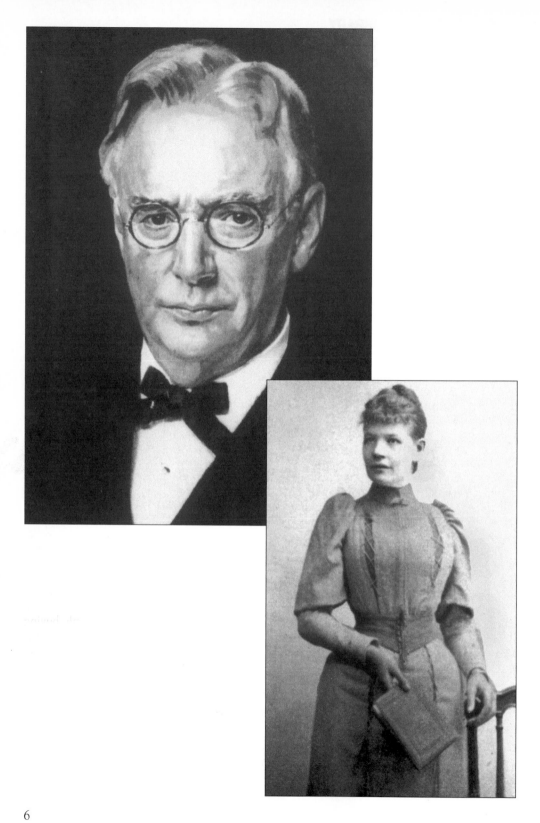

INTRODUCTION

Pleased with the success of *German Chicago: The Danube Swabians and the American Aid Societies*, Arcadia asked me to do another volume, to "revisit" the German Americans of Chicago, concentrating on more contemporary images, which is not as easy to do as it might sound. This has become much more of a "submerged" and stigmatized community since World Wars I and II, as the troubled look on the great civic leader Dr. Otto L. Schmidt's face might suggest to the left.

It was not always this way; in fact, there is an encyclopedia of Chicago's German Americans on the shelf at UIC's Richard J. Daley Library. *Chicago und sein Deutschtum*, replete with gold-leaf edges, was published in 1902 by the German-American Biographical Publishing Company, and is the equivalent of a stylish *Who's Who* for them. In many ways it reveals the core values and contributions of this particular ethnic group.

This book is not that kind of effort. It is a purely photographic study, designed to impart a better "feel" for what this community represents in Chicago, and hopefully, by inference, in the rest of America. I created it with the idea *lex imaginis* in mind, and hope to present the contemporary *Deutsch Amerikaners* in a less glaring and far more illuminating light.

Jane Addams wrote in *Twenty Years at Hull House* of her admiration for Albrecht Dürer, saying she apprehended his "wonderful pictures, however, in the most unorthodox manner, merely as human documents." I would like to ask the reader to see these photographs in the same way.

Deutsch Amerikaner represents a complex, variegated 'ethnicity' that deserves careful definition and exploration by American ethnic-historians, especially since it is the largest 'ethnic' group in America today. Where Otto Schmidt lived, and where Erich Himmel lives today, is in the *Deutsch Amerikaner* community of Chicago, imagined or not. As President of the German Day Organization, among other things, it is very natural to begin with him, and leave Dr. Otto Schmidt on the shelf. Whether Himmel is seated beside Cardinal George and Princess Renate zu Windisch-Graetz at a German concert in an Irish Hall, or simply buying drinks at the Brauhaus in Lincoln Square, he is a man that lives for, and is typical of, the Windy City *Deutsch Amerikaners*. For that reason I begin this photo-study with him, and move on to the 'submerged' collective he generally represents.

So then, please page through slowly, and let each picture say a thousand words to you, and hopefully, the old and the new will converge and a part of the saga of Chicago and the Germans will be revealed to you in that inexpressible language that photographs seem to speak.

(opposite, top) **DR. OTTO SCHMIDT, CIVIC LEADER IN CHICAGO, C. 1880.**
(opposite, bottom) **MISS REBECCA DORMEYER.** Dormeyer's education apparently began in Berlin, Paris, and London at various universities, opened a Preparatory and Collegiate School on La Salle Avenue in 1897.

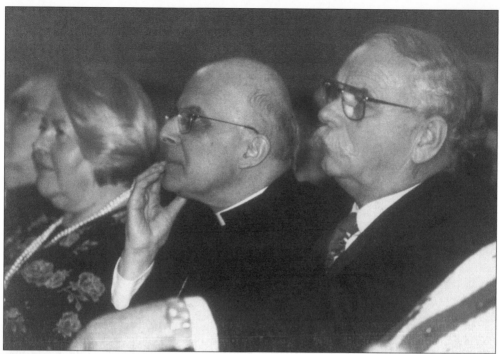

HIS EXCELLENCY CARDINAL FRANCIS GEORGE WITH ERICH HIMMEL AT THE IRISH AMERICAN HERITAGE CENTER, CHICAGO, IL, CHRISTMAS, 1999.

ERICH HIMMEL AT THE BRAUHAUS, CHICAGO, IL, DECEMBER 1999. (Photographs courtesy of Raymond Lohne.)

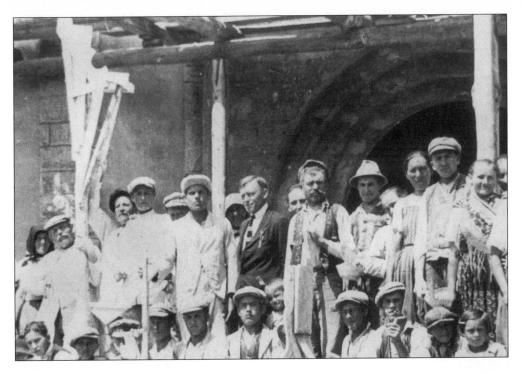

PROBEN, AUSTRIA-HUNGARY TO WILMETTE, IL. The immigration story of the Ceisel clan is typical of what becomes of the *Deutsch Amerikaners*. (Photographs courtesy of Dr. Joseph Ceisel, D.D.S.)

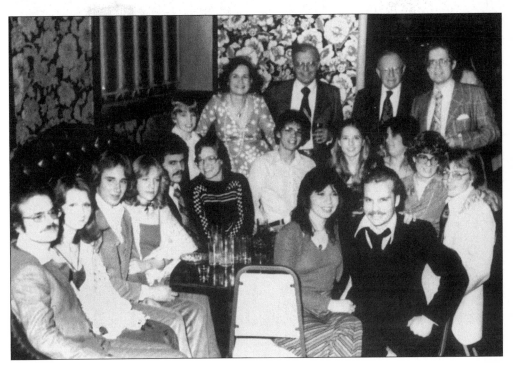

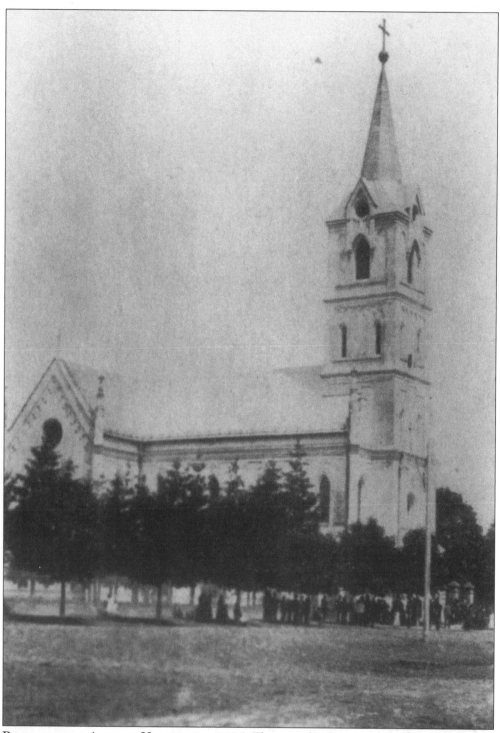

RUDOLFSGNAD, AUSTRIA-HUNGARY, C. 1875. There is a large community of the people who came from this village now living in America, especially in Chicago. (Photograph courtesy of Magdalena Ippach.)

One

THE RHEINISCHER VEREIN KARNEVAL GESELLSCHAFT

Anyone who has ever attended Mardi Gras will immediately understand what this organization is all about. It's about having fun, though it takes lots of hard work to make it happen year after year. In 1990 Erich Himmel was required to comment upon the 100th anniversary of the founding of the KGRV. As president of the organization at that time he said the following:

"One hundred years of the Karneval Society in Chicago. In a quiet moment, shut your eyes and meditate on this. The Machine Age began in the same year our society was founded. The Jet Age began during our 60th year, and as we celebrated our 80th year American astronauts stood for the first time on the moon. Two world wars, a world-wide economic crisis and a Prohibition which cut us to the quick also befell our society. Nevertheless, and even in spite of it all, the *Rheinischer Karneval* remained a powerful element in Chicago. *Alle wohl und niemand wehe.* Our motto has shown its worth from 1890 until 1990 and the friendly relations between the United States and the Federal Republic of Germany is proof enough of that."

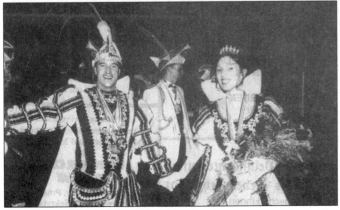

PRINZ CORNEL I AND PRINZESSIN SONJA I. They are the reigning 'royal' couple for the 2000-2001 carnival season in Chicago and its suburbs. Their real names are Cornel Erdbeer and Sonja Meisen. (Photograph taken from the *Eintracht.*)

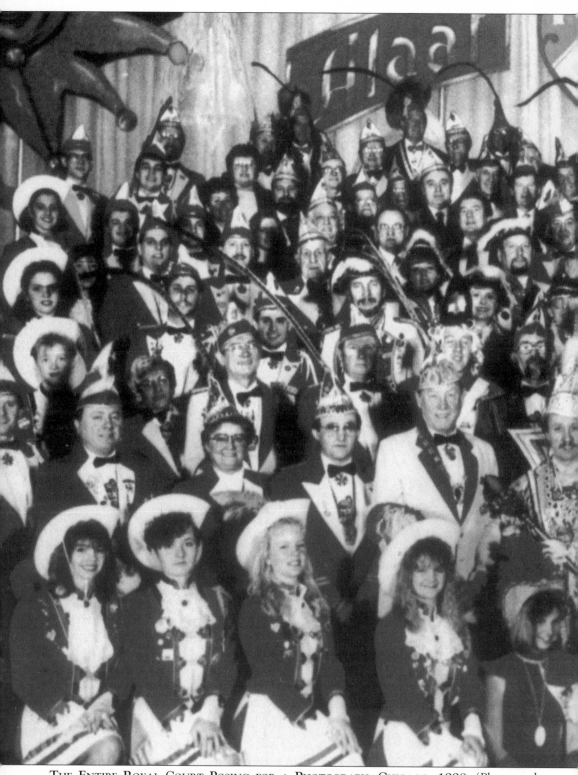

The Entire Royal Court Posing for a Photograph, Chicago, 1998. (Photograph

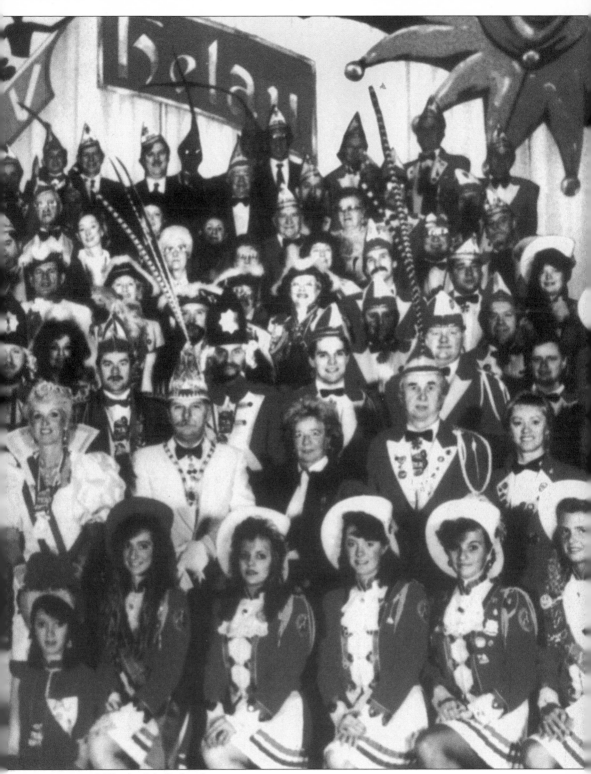

courtesy of Charles M. Barber.)

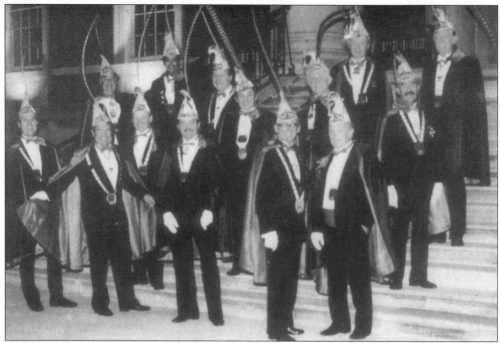

CHICAGO, 1990. Here the men pause for a snapshot in full regalia. (Photograph courtesy of Charles M. Barber.)

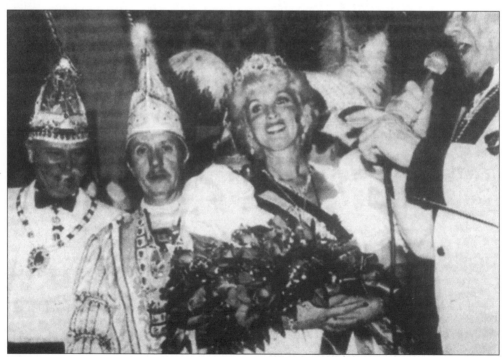

ERICH HIMMEL, CHICAGO, 1995. The Prince and Princess are announced to the crowd by the Master of Ceremonies, while Himmel, far left, offers his characteristic smile. (Photograph courtesy Charles M. Barber.)

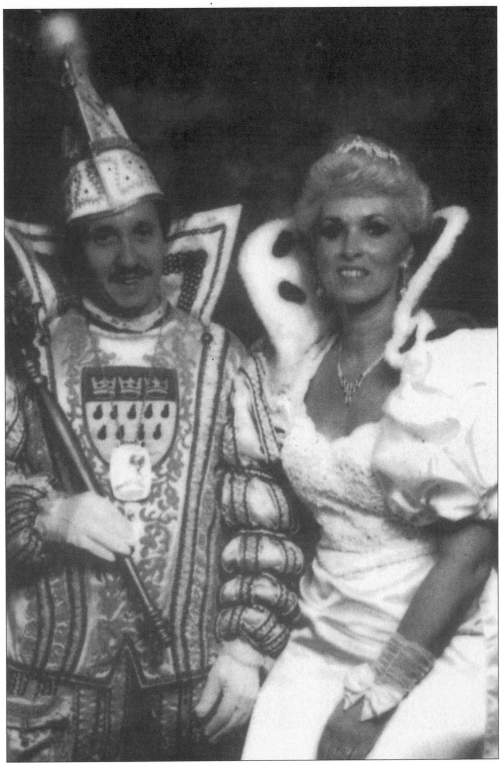

PRINCE JOHANN AND PRINCESS ERIKA, CHICAGO. (Photograph courtesy of Charles M. Barber.)

AMAZONEN UND FANFAREN, CHICAGO, 1990. (Photographs courtesy of Charles M. Barber.)

Two
The *Kerneier*
Pleasure Club

Today the town of Kernei no longer exists. The Germans of this town were rounded up after World War II and either killed, put into concentration camps, or shipped off to Russia as slaves. Michael Stöckl was one of those people. I believe he is the premier historian of Kernei and the Kerneier Pleasure Club in Chicago. He is also the man who put together the priceless volumes of the *Neuland*, from 1948–1979, and who has given me permission to place them in the Special Collections of the University Library of UIC when I'm finished with them.

Michael would be the first to point out that as a club, Kerneiers are not many, but they are still in existence. If that seems a little odd for a village which has disappeared from the world's maps, think for a moment to your childhood and the locale it took place in. Could you ever forget it?

The 'Main Street' scene at right, by A. Roth of Kernei, drawn in 1964, is typical of the kinds of artwork found in their self-published festival books.

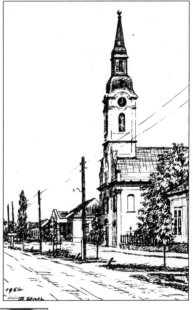

Michael Stöckl, with Margaret Gunther, at the American Aid Society Picnic Grounds, August 8, 2000. (Photograph courtesy of Raymond Lohne.)

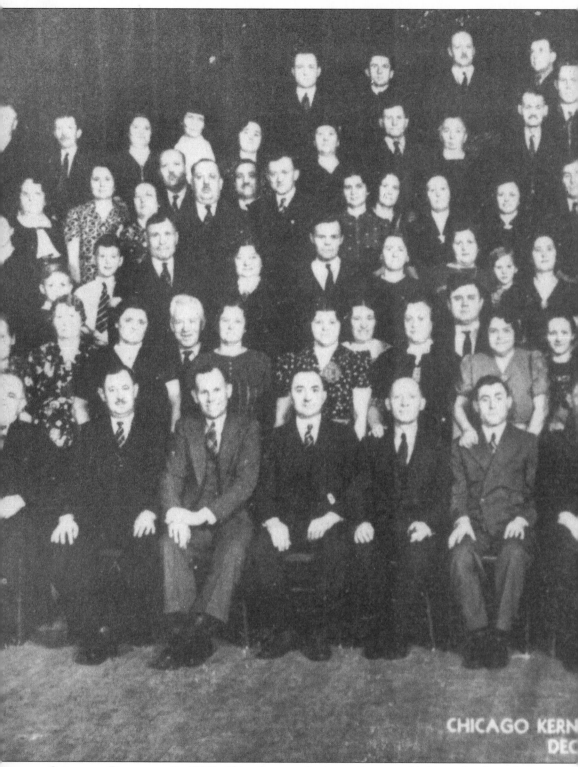

CHICAGO, DECEMBER 9, 1938. This photograph shows the assembled membership of the

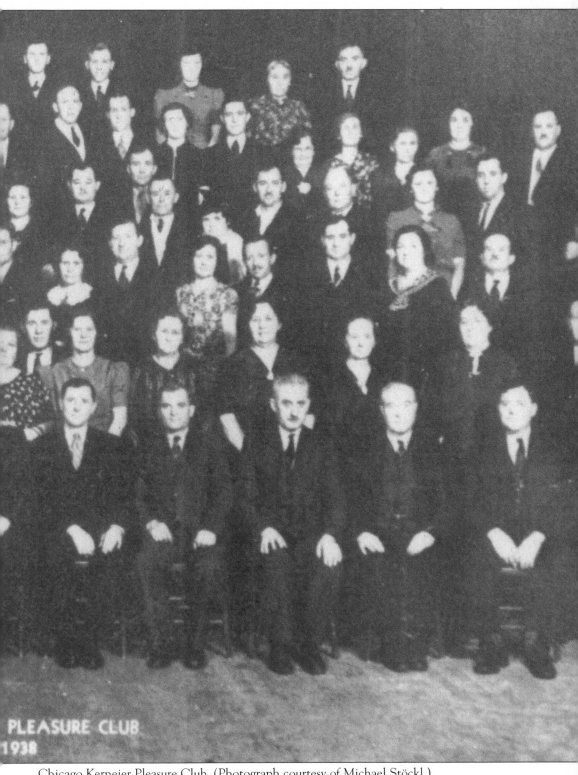

Chicago Kerneier Pleasure Club. (Photograph courtesy of Michael Stöckl.)

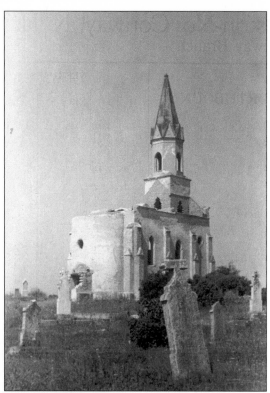

CATHOLIC CHURCH AND CEMETERY, KERNEI, C. 1960. During trips back to see the ruins of their old homeland, Kerneiers inevitably cannot resist photographing the churches that meant so much to them. Here is a picture of one chapel in decay in the former Yugoslavia. (Photograph courtesy of Michael Stöckl.)

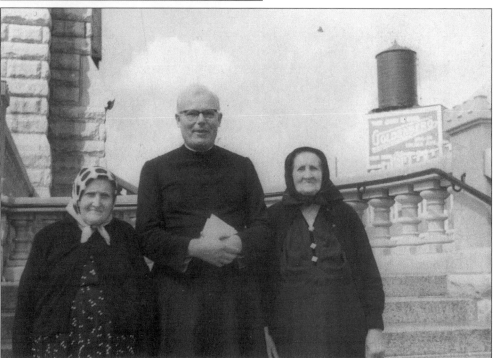

CHICAGO, 1961. Here is a priest at St. Alphonse Catholic Church with two of the faithful. (Photograph courtesy of Michael Stöckl.)

CHICAGO, C. 1980. A group of Kerneirs are celebrating. Michael Stöckl is in the back row, second from the left, and Irene Rotter is directly below him—the only woman allowed with the men. (Photograph courtesy of Michael Stöckl.)

CHICAGO, C. 1980. This photograph shows the ladies of the club. Irene Rotter is third from the left in the front row. (Photograph courtesy of Michael Stöckl.)

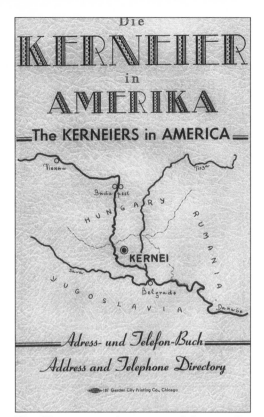

THE KERNEIER IN AMERIKA, BY MICHAEL STÖCKL. At right, a painting in one of the chapels in Kernei is shown. For some reason, this map—drawn by Michael and vastly enlarging the size of the small village—appeared exactly like this in the *Harvard Encyclopedia of American Ethnic Groups*.

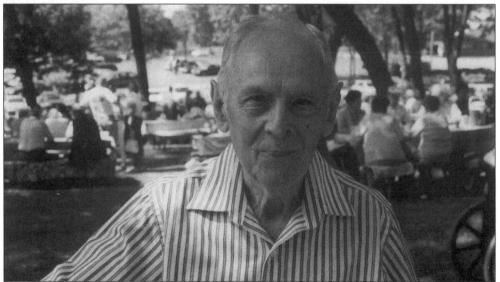

MICHAEL STÖCKL, SUMMER 2000. The survivor of Stanlino stands reluctantly for a photo at the picnic grounds of the American Aid Society, Lake Villa, IL. (Photograph courtesy of Raymond Lohne.)

Three

THE AMERICAN AID SOCIETY OF GERMAN DESCENDANTS

I wrote the history of this organization in *The Great Chicago Refugee Rescue*, and it is an honor to present them again visually, for they are very much alive in Chicago at the turn of the millennium. The stamp at right was created *c.* 1947, in Austria most likely, and says: "Danube Swabians: A peasant people seeks work, land and a home."

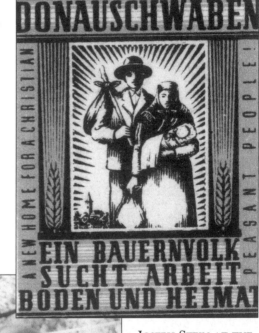

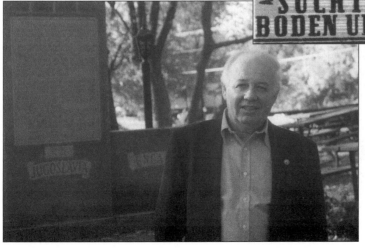

JOSEPH STEIN AT THE NICK PESCH MEMORIAL, AMERICAN AID SOCIETY PICNIC GROUNDS, LAKE VILLA, IL. KIRCHWEIHE, 1999. Joe was my first teacher among the Donauschwaben. (Photograph courtesy of Raymond Lohne.)

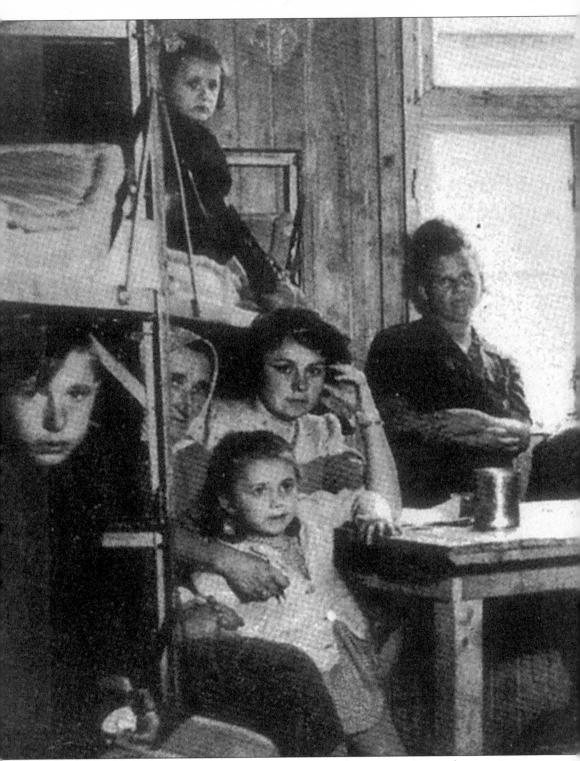

GERMAN REFUGEES, C. 1947. Many of the Danube Swabians spent up to eight years in rooms like these while the American Aid Societies lobbied the United States Congress in their behalf.

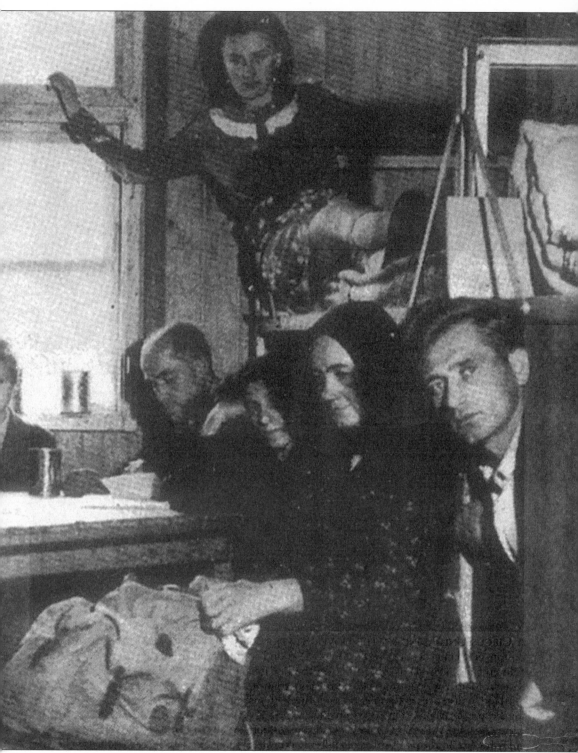

(Photograph courtesy of the Society of the Danube Swabians.)

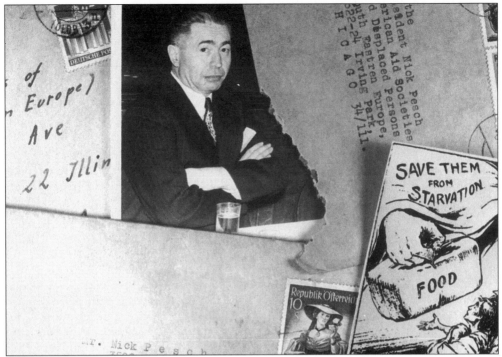

NICK PESCH, C. 1950. Here he is, surrounded by the letters for help that must have tormented him during the eight-year long struggle he fought to save his people. (Photo collage courtesy of the American Aid Society and Raymond Lohne.)

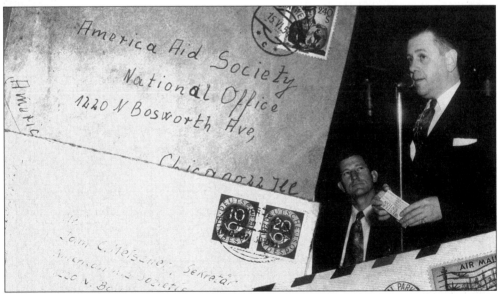

JOHN MEISZNER, C. 1950. Here he is speaking while the displaced persons commissioner, John Gibson, Listens. Meiszner's political connections were undoubtedly the reason that the American Aid Society succeeded. Meiszner's best friend was Illinois Senator Everett McKinley Dirksen, the Honorable Mr. Marigold. (Photo collage courtesy of the American Aid Society and Raymond Lohne.)

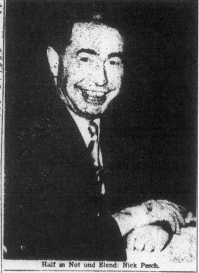

NICK PESCH, C. 1967. In a rare photograph of him, the founder of the American Aid Societies smiles because he is getting the highest honor his people can give him: the Golden Pin of Honor with Diamond. (Photograph courtesy of Dorothy Pesch.)

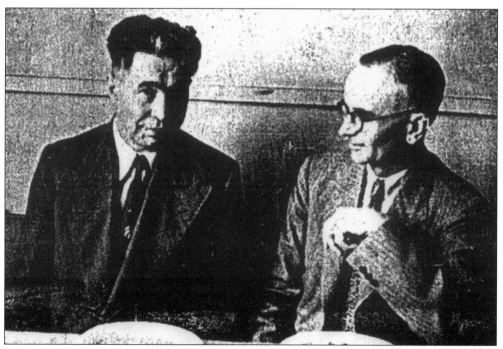

NICK PESCH, JULY 1949, STUTTGART-ZUFFENHAUSEN. Here he is, looking characteristically grim, during his tour of European refugee camps. He made films while he was in Europe. One day these will be seen in a documentary film about this entire humanitarian episode in American and European history. (Photograph courtesy of Dorothy Pesch.)

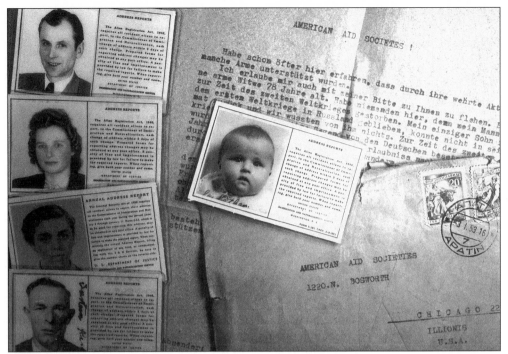

IDENTITY CARDS, C. 1952. These are typical documents found in the records of the American Aid Society, which I have placed in the Special Collections of the University Library at UIC. (Photograph collage by Raymond Lohne.)

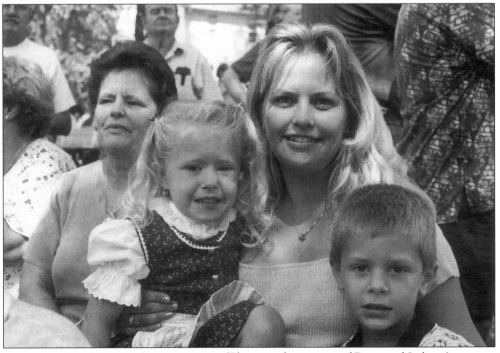

AMERICAN AID SOCIETY, SUMMER 2000. (Photograph courtesy of Raymond Lohne.)

NICOLE MÜLLER, ANTON MÜLLER, AND LUCAS MÜLLER, AT THE AMERICAN AID SOCIETY, AUGUST 2000. (Photograph courtesy of Raymond Lohne.)

THE WALTER BROTHERS, NICK PESCH MEMORIAL, SUMMER 2000. (Photograph courtesy of Raymond Lohne.)

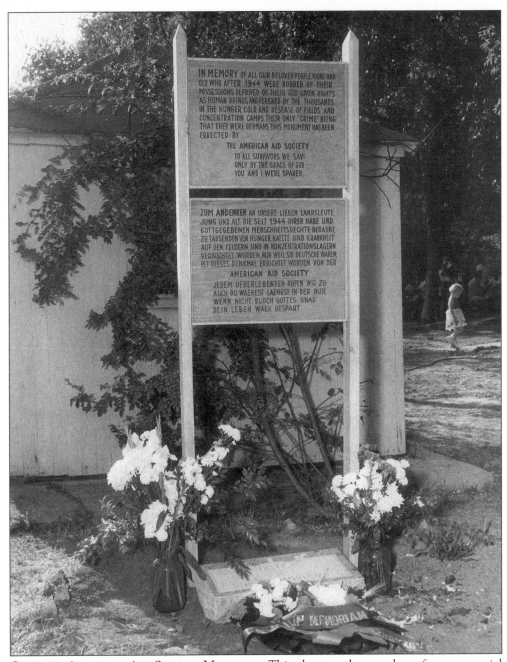

ORIGINAL AMERICAN AID SOCIETY MEMORIAL. This photograph was taken after a memorial service for Illinois Senator Everett McKinley Dirksen. (Photograph courtesy of the American Aid Society.)

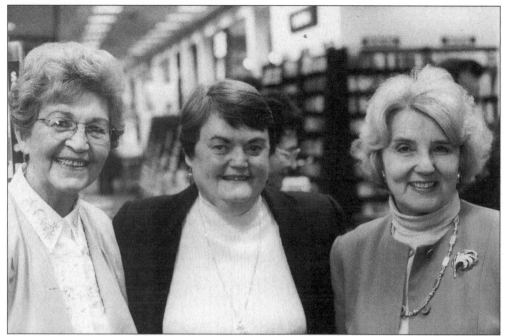

ELSA WALTER, MAGDALENA IPPACH, AND AGNES VARDY, SQUIRREL HILL BARNES AND
NOBLE, PITTSBURGH, NOVEMBER 15, 2000. Walter and Ippach flew in for the book signing
and Conference on Ethnic Cleansing at Duquesne University. Vardy is the author of *Mimi*.
Magdalena is from Rudolfsgnad. (Photograph courtesy of Raymond Lohne.)

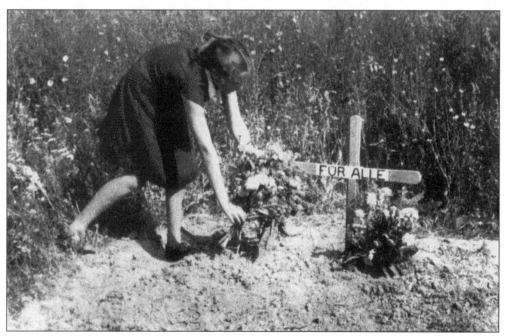

RUDOLFSGNAD, YUGOSLAVIA, C. 1948. She is laying flowers at one of the mass graves outside
this village. Much better than flowers, however, would have been an identifying land mark.
(Photograph courtesy of Magdalena Ippach.)

SAM BAUMANN WITH CONGRESSMAN TIM SHEEHAN, 11TH DISTRICT, C. 1953. John and Joyce Meiszner are at the right. (Photograph courtesy of the Meiszner family.)

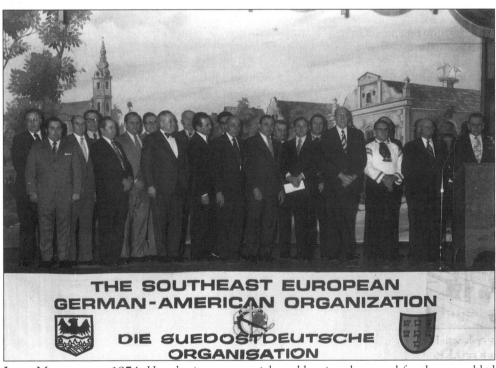

JOHN MEISZNER, C. 1974. Here he is, extreme right, addressing the crowd for the assembled members of this group—one of many Meiszner belonged to. (Photograph courtesy of the Meiszner family.)

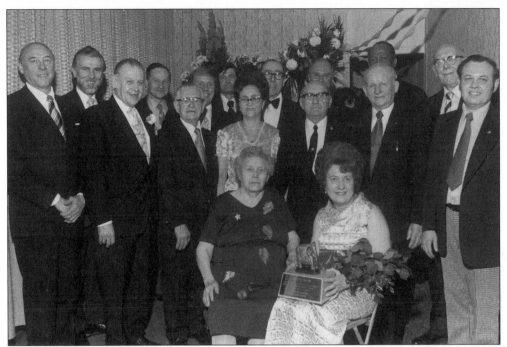

JOHN AND HELEN MEISZNER, CHICAGO, 1974. Here Helen is holding an award which John received for his service to the community. (Photograph courtesy of the Meiszner family.)

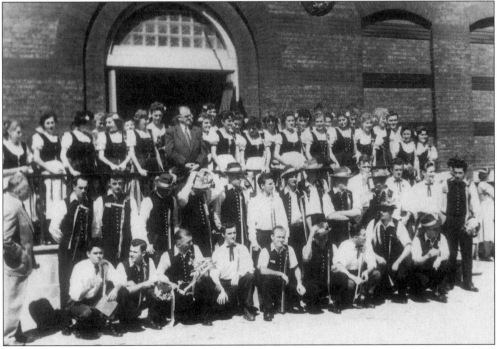

ST. LOUIS, 1957. The American Aid Society Youth Group attend a Kirchweihe in St. Louis in 1957. Dr. Ludwik Leber, a *Fluchtlingseelsorger*, or refugee pastor from Germany, is in the gray suit in the third row. (Photograph courtesy of the American Aid Society.)

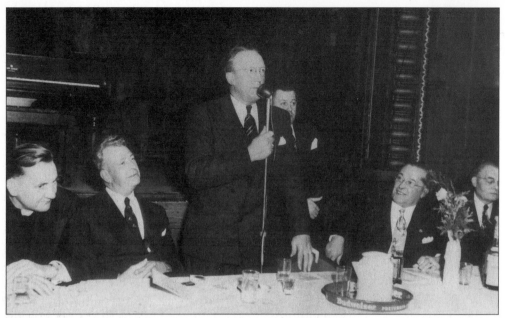

SENATOR EVERETT MCKINLEY DIRKSEN, CHICAGO, 1950. He is seated next to the priest on the left, Monsignor Swanstrom. Dirksen was the key player, along with Senator William Langer, in helping the American Aid Society achieve its goals. (Photograph courtesy of Meiszner family.)

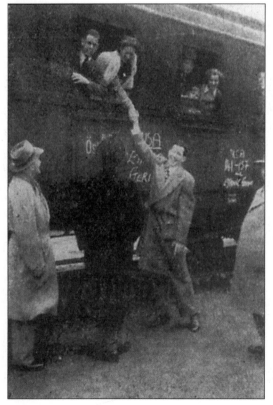

JOHN GIBSON, DISPLACED PERSONS COMMISSIONER, AUSTRIA, 1952, WITH A TRAIN OF GRATEFUL GERMAN REFUGEES BOUND FOR AMERICA. Gibson was later photographed with Harry Truman, Nick Pesch, and others in the Oval Office. (Photograph taken from the *Neuland*.)

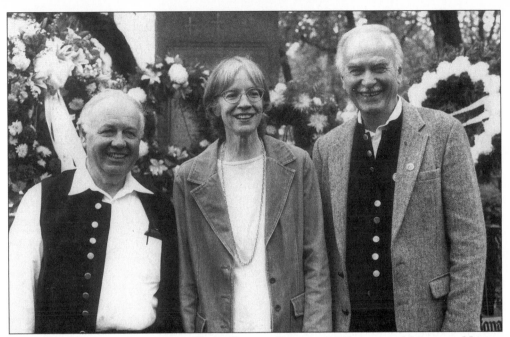

JOE STEIN, DOROTHY PESCH, AND HANS GEBAVI, SUMMER 2000, AT THE MEMORIAL NAMED AFTER HER FATHER. (Photograph courtesy of Raymond Lohne.)

JOYCE AND HELEN MEISZNER, FALL 1999. (Photograph courtesy of Raymond Lohne.)

WALTER SCHEFFRAN AND FAMILY. Walter is the vice president of the American Aid Society and publisher of the *Bulletin*, the official publication of the A.A.S. (Photograph courtesy of Raymond Lohne.)

AMERICAN AID SOCIETY, SUMMER 2000. (Photograph courtesy of Raymond Lohne.)

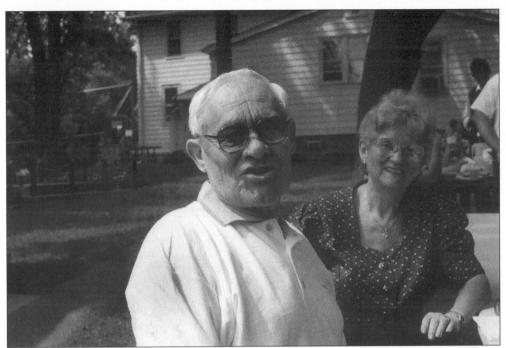

NICK FRITZ AND CATHERINE GROSSKOPF, AMERICAN AID SOCIETY PICNIC GROUNDS, SUMMER 2000. (Photograph courtesy of Raymond Lohne.)

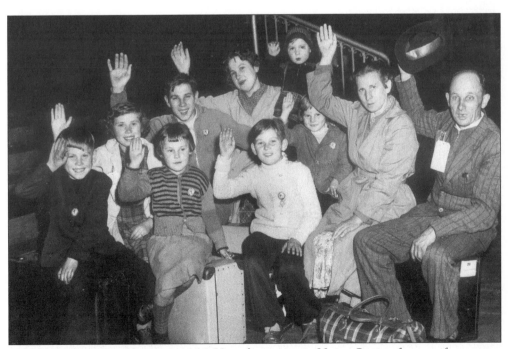

THE CSAPO FAMILY, CHICAGO, 1956. Here they arrive in Union Station from a refugee camp in Austria, under the provisions of the Refugee Relief Act of 1953. Joyce Meiszner was eventually to marry Andy Csapo. (Photograph courtesy of the Meiszner family.)

AMERICAN AID SOCIETY, C. 1957. The *Strauss*, or holy rosemary bush, is carried in parade to the stage, where the whole group will dance and auction off the bush. (Photograph courtesy of

the American Aid Society.)

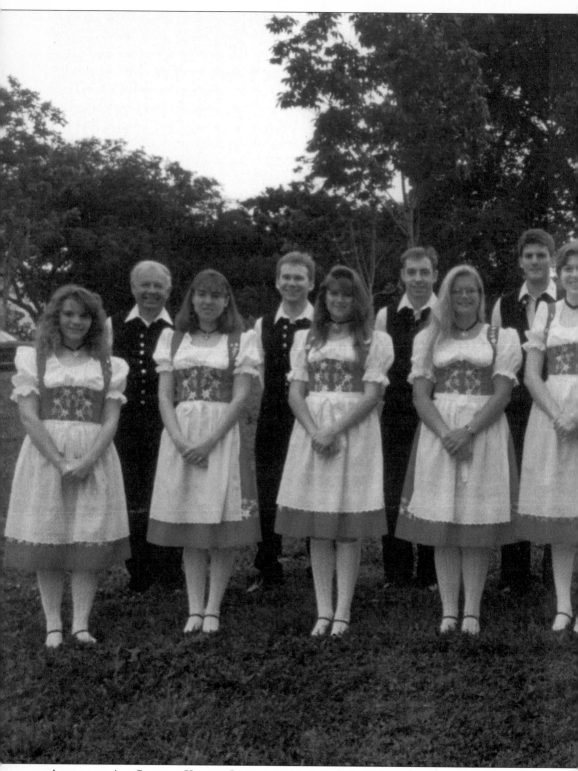

AMERICAN AID SOCIETY YOUTH GROUP, 1996. Joseph Stein is at the far right. (Photograph

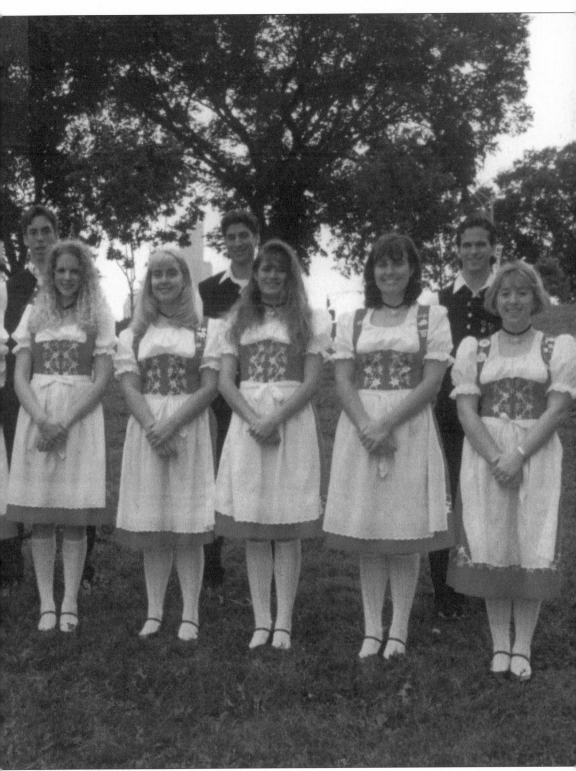

courtesy of the American Aid Society.)

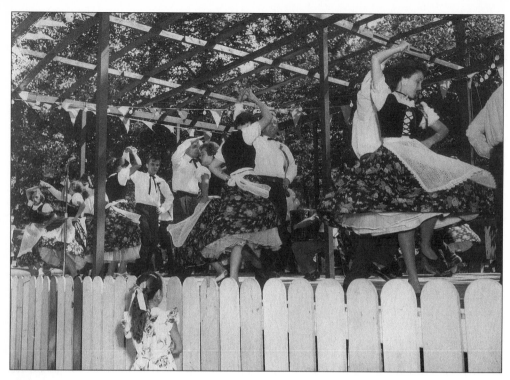

RIVERVIEW PARK, CHICAGO, C. 1957. The young girl is studying carefully. In a few years she will probably master the dances of the Donauschwaben. Below is a snapshot from the late fifties, showing a healthy crowd in the summer. (Photographs courtesy of the American Aid Society.)

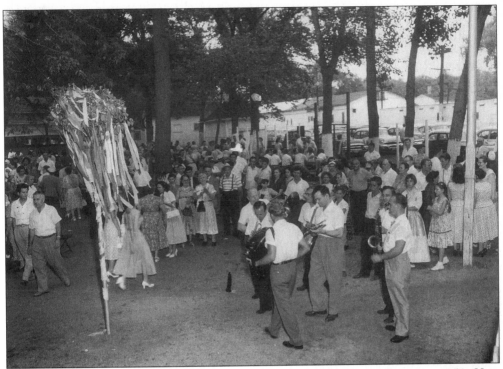

RICHARD GUNTHER, CENTER, AMERICAN AID SOCIETY, RIVERVIEW PARK, C. 1952. Here Gunther leads a band. (Photograph courtesy of Raymond Lohne.)

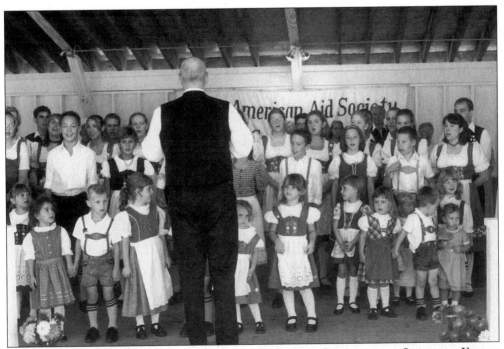

FRED MUELLER, AMERICAN AID SOCIETY, SUMMER 2000, PREPARING TO LEAD THE YOUTH IN SONG. (Photograph courtesy of Raymond Lohne.)

AMERICAN AID SOCIETY YOUTH GROUP, SUMMER 2000. They are preparing to go onstage. (Photograph courtesy of Raymond Lohne.)

AMERICAN AID SOCIETY, SUMMER 2000. (Photograph courtesy of Raymond Lohne.)

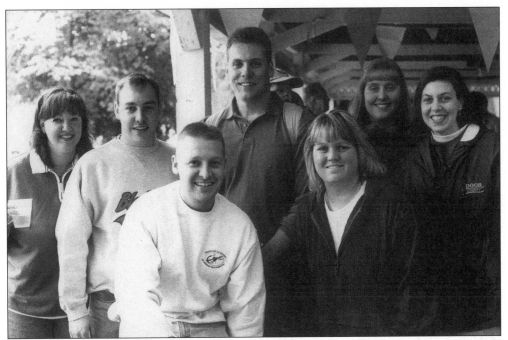

AMERICAN AID SOCIETY, SUMMER 2000. (Photograph courtesy of Raymond Lohne.)

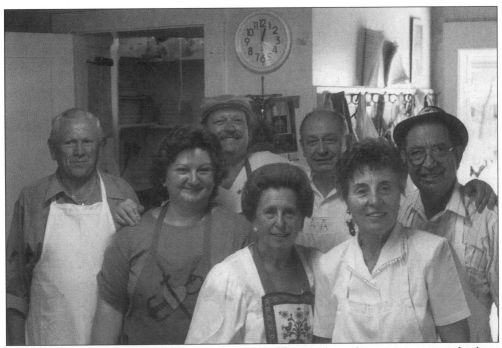

AMERICAN AID SOCIETY, SUMMER 2000. The hardest workers always seem to get the least credit. The kitchen volunteers deserve a photo opportunity in my book. (Photograph courtesy of Raymond Lohne.)

AMERICAN AID SOCIETY, FALL 2000. (Photograph courtesy of Raymond Lohne.)

AMERICAN AID SOCIETY, SUMMER 1999. (Photograph courtesy of Raymond Lohne.)

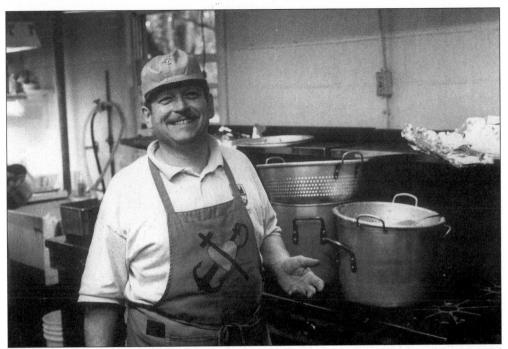

MIKE GLASENHARDT, SUMMER 2000. One of the hardest working men at the American Aid Society is the son of Katherine Glasenhardt, one of the hardest working women I've ever met. (Photograph courtesy of Raymond Lohne.)

AMERICAN AID SOCIETY, SUMMER 2000. (Photograph courtesy of Raymond Lohne.)

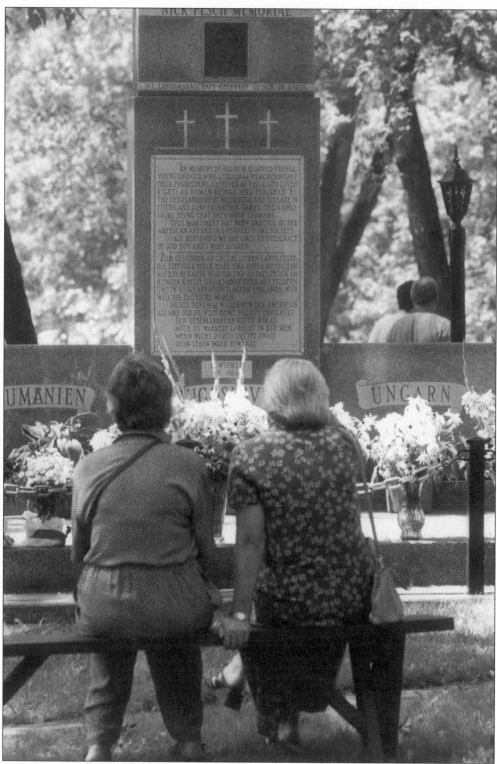

NICK PESCH MEMORIAL, SUMMER 1999. (Photograph courtesy of Raymond Lohne.)

Four
THE SOCIETY OF THE
DANUBE SWABIANS

The poem says: "We plow and spread seed upon the land, but growth and success, that is in God's hand." This organization was born after the American Aid Society saga which I described in *The Great Chicago Refugee Rescue*. The history of how this came to be a separate group apart from the American Aid Society is still not written and somewhat hotly debated by both sides. What is not in dispute, by either society, is that they are essentially one people. Perhaps they can reconnect to each other some day.

Wir pflügen und wir ftreuen den Samen auf das Land, doch Wachstum und Gedeihen, das ftcht in Gottes Hand.

NIKOLAUS KREILING, PRESIDENT OF THE SOCIETY OF THE DANUBE SWABIANS, WITH HIS WIFE AND GRANDSON ON THE GROUNDS OF THE AMERICAN AID SOCIETY, LAKE VILLA, IL, SUMMER, 2000. (Photograph courtesy of Raymond Lohne.)

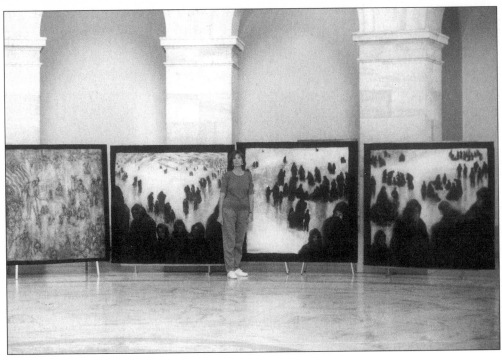

SUSANNA TSCHURTZ. Above, Susanna shows her work at an exhibit on Ethnic Cleansing in the Senate Russell Building, Washington D.C., October, 12–16, 1998. She was born in the Romanian village of Morawitza, and as a refuge spent 8 years in Austria before she emigrated to the U.S. in 1952. A graduate of Northwestern University, she attended the Art Institute of Chicago. (Photographs courtesy of artist and Martha Prekop, Pittsburgh, PA.)

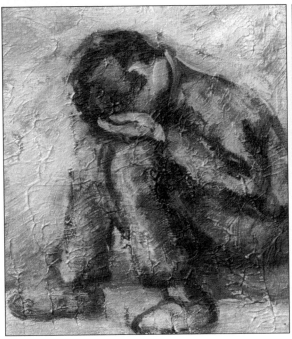

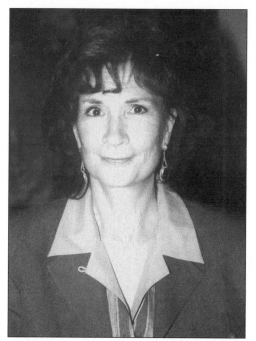

SUSANNA TSCHURTZ, LEFT, AND HER GRANDSON, PAUL, AT RIGHT. Below is a painting she entitled *Rumanian Blouse*. Susanna's most recent paintings were shown at Duquesne University's 34th Annual History Forum, at the Conference on Ethnic Cleansing in Twentieth-Century Europe, by this writer. (Photographs courtesy of artist.)

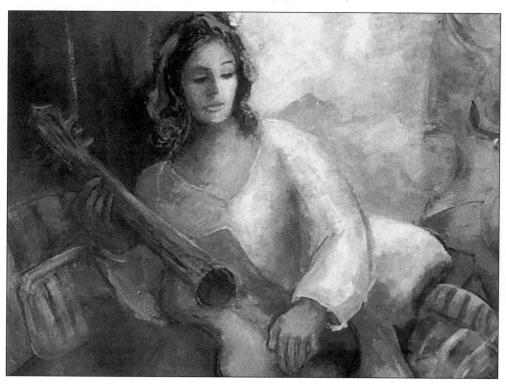

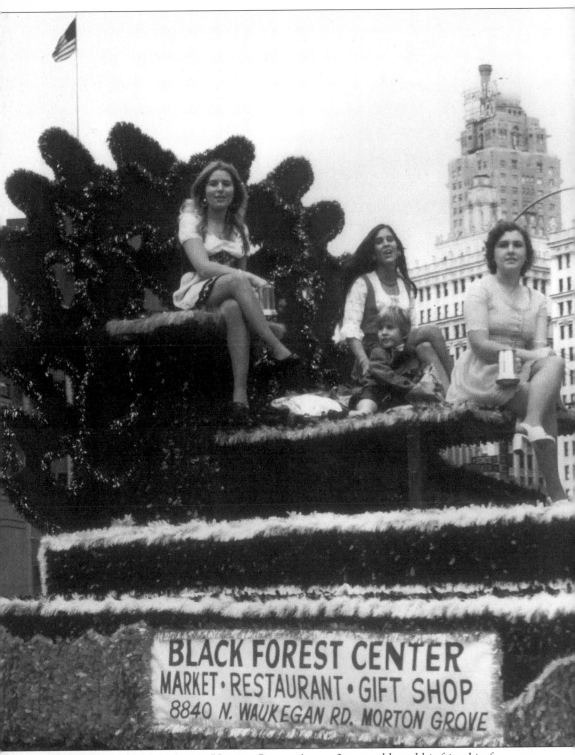

PETER TSCHURTZ AND ANNIE UNGER. Susanna's son, 3 years old, and his friend in front, age 7, ride the float of the Black Forest Center, Steuben Day Parade, Chicago, 1972. (Photograph

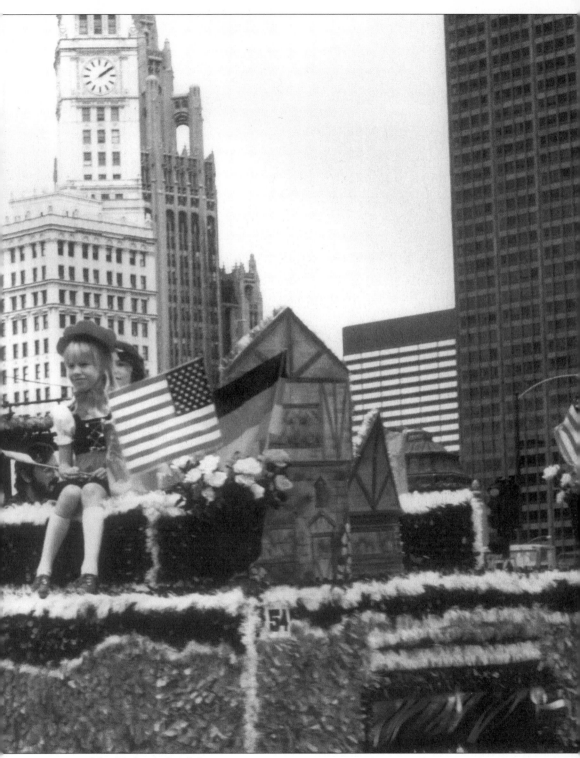

courtesy of the Tschurtz family)

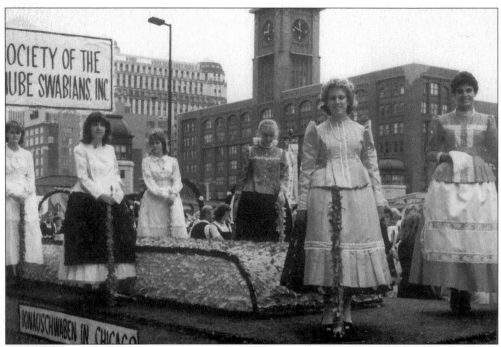

CHICAGO, C. 1972. This is the Society of the Danube Swabian's float for the Steuben Day Parade. (Photograph courtesy of the Society of the Danube Swabians.)

CHICAGO, C. 1975. The princesses are standing for a group shot. (Photograph courtesy of the Society of the Danube Swabians.)

JIM EDGAR AND STEFAN KUNZER, PRESIDENT OF THE SOCIETY OF THE DANUBE SWABIANS, LAKE VILLA, C. 1972. (Photograph courtesy of the Society of the Danube Swabians.)

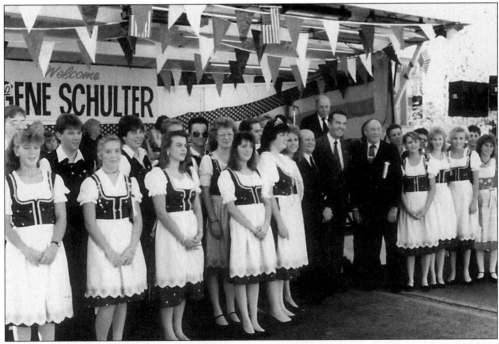

EUGENE SCHULTER WITH THE YOUTH GROUP, CHICAGO, C. 1972 . (Photograph courtesy of the Society of the Danube Swabians.)

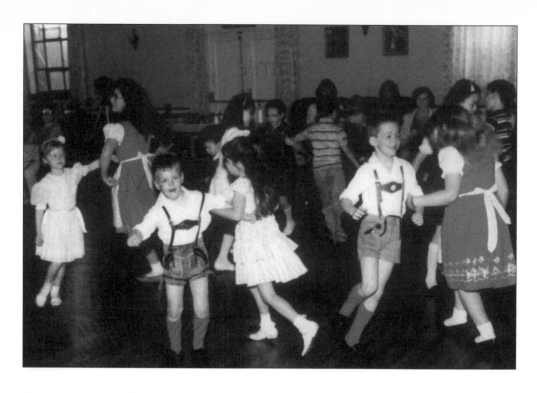

CHILDREN OF THE SOCIETY OF THE DANUBE SWABIANS, CHICAGO, C. 1974. (Photographs courtesy of the Society of the Danube Swabians.)

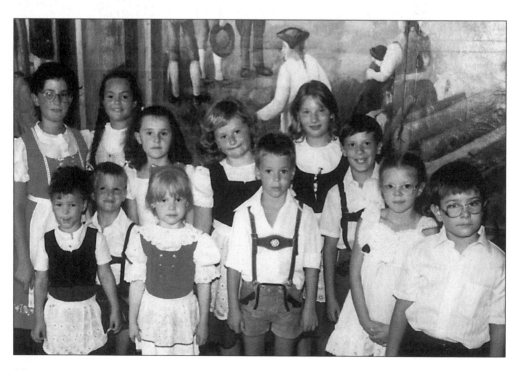

SOCIETY OF THE DANUBE SWABIANS, C. 1974. (Photograph courtesy of the Society of the Danube Swabians.)

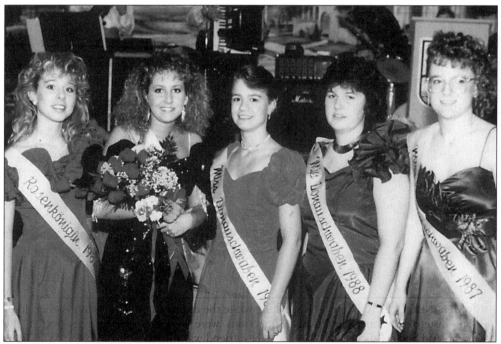

SOCIETY OF THE DANUBE SWABIANS, C. 1990. (Photograph courtesy of the Society of the Danube Swabians.)

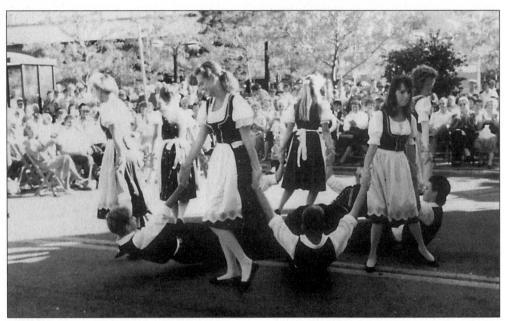

SOCIETY OF THE DANUBE SWABIANS, CHICAGO, C. 1972. Here the dance shows women capable of carrying the men, if need be. (Photograph courtesy of the Society of the Danube Swabians.)

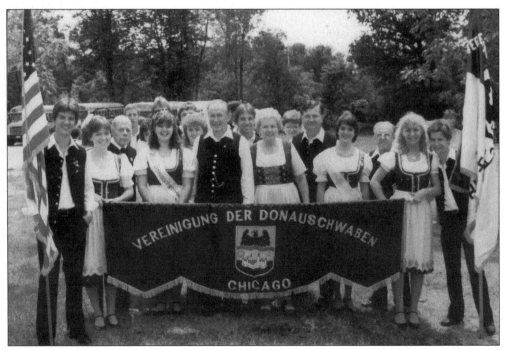

SOCIETY OF THE DANUBE SWABIANS, C. 1972. (Photograph courtesy of the Society of the Danube Swabians.)

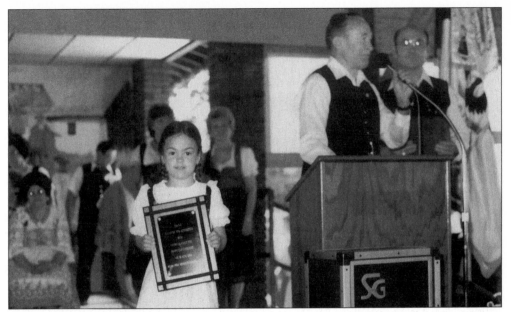

STEFAN KUNZER, C. 1975. Here the president has just awarded a young girl a plaque. (Photograph courtesy of the Society of the Danube Swabians.)

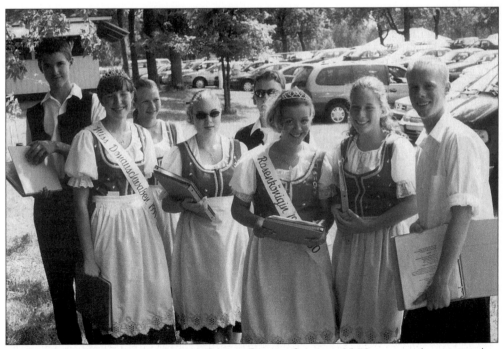

SOCIETY OF THE DANUBE SWABIANS, YOUTH GROUP, SUMMER 2000, AT THE AMERICAN AID SOCIETY PICNIC GROUNDS, JUST BEFORE GOING ON-STAGE. (Photograph courtesy of Raymond Lohne.)

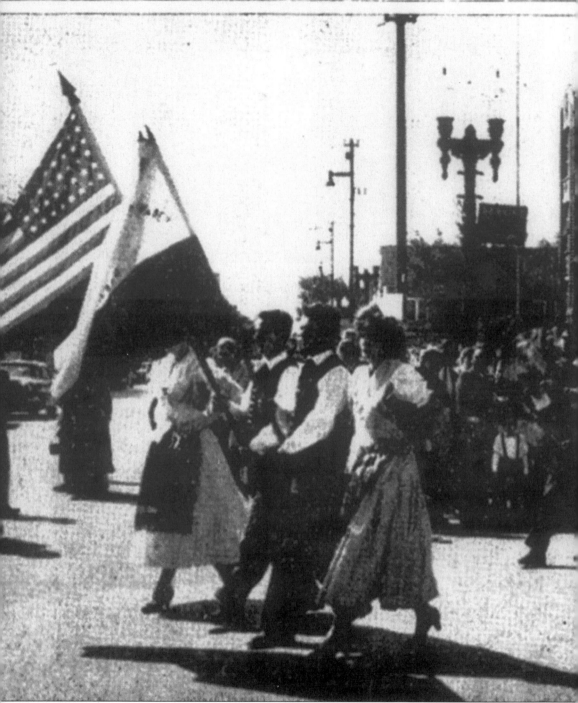

NACHRICHTEN, C. 1958, ST. ALPHONSE CATHOLIC CHURCH. This is the "march of the traditional costumes" after the festival mass on the Day of the Donauschwaben in Chicago,

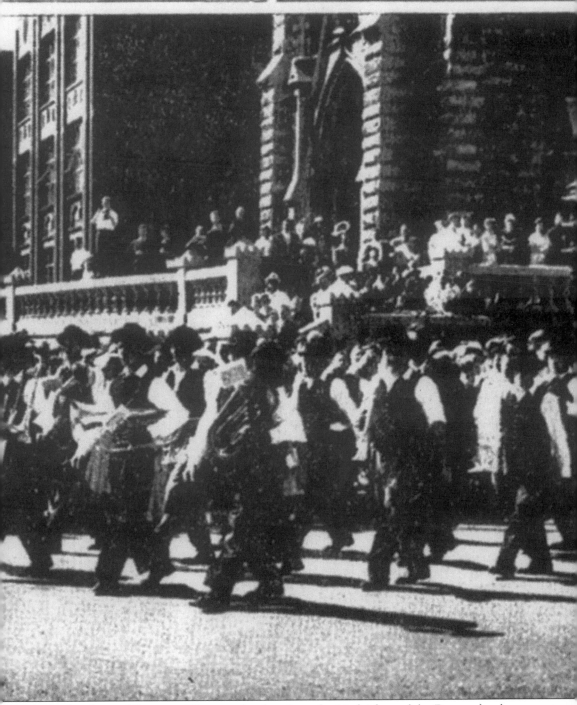

with a band out of Toronto. (Photograph taken from the *Nachrichten* of the Donauschwaben, USA.)

Nachrichten

MONATSCHRIFT DER DONAUSCHWABEN

Donauschwabentag 1959.
Erinnerung an Cleveland.
Dr. Kraft gestorben.
Schuleinschreibung.

SOCIETY OF THE DANUBE SWABIAN
of the United States of America, I
4384 N. Elston Avenue, Chicago 41,

Chicago, im Juli 1959 Nr.

...ater Volksfest" in Cleveland

bevorstehendes Er-
er so beunruhigt. Vol-
ohl auch etwas unge-
man im Lager unse-
der Fussballabteilung
Mehr als 70 Personen
ung fanden sich ein,
Morgengrauen ging's
Klängen, die Fredy's
meisterhaft begleitete,
Die etwas holprige
motone Rhytmus der
lasste bald die etwas
mauchten Teilnehmer,
hen. In nicht gerade
t entstanden dann die

ay newrem Graawe
Schwowe gfahre,
is uff Cleveland;
doch allerhand! usw.
in
af
ar-
n-
ass
u-
e-
ste
ür
e-
ar-
er
gs

WIR DANKEN EUCH

Clevelander Donauschwaben!

*Weil es für Eure ausgezeichnete
Gastfreundschaft eigentlich gar kei-
nen Ausdruck des Dankes gibt, wol-
len wir Euch diese Zeilen widmen:
In rührender Herzlichkeit habt Ihr
uns für zwei Tage mehr als nur Ob-
dach und Verpflegung gegeben. Ihr
habt uns ein Stück der alten Heimat*

gefüllt mit Landsleuten. Eine flotte
Musik sorgte für Stimmung, die später
durch den Trachteneinmarsch unserer
Chicagoer Jugendgruppe einen für die
dortigen Verhältnisse seltenen Höhe-
punkt erreichte. Brausender Applaus
belohnte die humorreichen Darbietun-
gen; die Lieder und Gedichte, ferner
die gutgewählten Sachen „Zum
Schmunzle un Lache" vorgetragen von
Marie **Kirschner**, Wilma **Lampen**, Hans
Neidenbach und dem Betreuer unserer
Jugendgruppe. Der nicht enden wol-
lende Applaus und die Stille während
den Vorträgen bewiesen, dass das Pro-
gramm begeistert aufgenommen wur-
de. Am darauffolgenden Tag rüstete
man für das „Banater Volksfest", das
draussen in einer wunderschönen Land-
schaft, der sgn. „Deutschen Zentrale"
stattfand. Der Einmarsch der Jugend-
gruppen in ihren
schmucken Heimat-
trachten, angeführt
von der Blaskapel-
le, bot ein farben-
frohes, vertrautes
Bild; tiefschlum-
mernde Heimater-
innerungen rückten
bei diesem wunder-
vollen Anblick in
das Blickfeld der
Gegenwart — sie

Das Flüchtlingsjahr und W

Von Joseph M. Funk

Die Vereinten Nationen haben d
Zeit von Juli 1959 bis Juli 1960 zu
„Weltflüchtlingsjahr" proklamiert. D
Sinn des Jahres ist es, die Weltöffen
lichkeit erneut auf das Flüchtling
problem zu lenken und zur tätigen Hi
fe zu bewegen. Somit soll das Gewi
sen aller, die guten Willens sin
wachgerüttelt werden. 37 Staate
haben sich bereit erklärt, ausserg

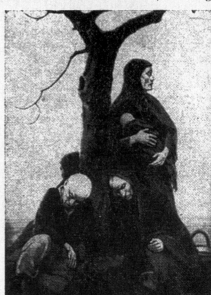

Rest der Flüchtlinge (Oskar Sommerfel

NACHRICHTEN, JULY 1959. This cover of the monthly features a painting by Oskar Sommerfeld entitled *Rest of the Refugees*. (Photograph taken from the *Nachrichten*.)

NACHRICHTEN, JUNE, 1958. The President of Germany visits Chicago's German community. (Opposite photograph taken from the *Nachrichten*.)

Nachrichten

MONATSCHRIFT DER DONAUSCHWABEN

ahrgang | Chicago, im Juni 1958

Bundespräsident Theodor Heuss bei den Deutschen in Chicago

In langem Gespräch mit den Donauschwaben

er seit langem erwartete Tag rückte iesslich heran und wir Deutschen hicago hatten das beglückende Er- is, **Theodor Heuss**, den Staatsprä- nten Deutschlands in unserer Mitte aben.

der. Von der donauschwäbischen Ju- gendgruppe erschienen **Franz Stadler mit Trude Kuhn, Toni Kirschner mit Ritta Bonval** und **Joe Schachelmay-** er mit **Heidrun Kilian** in **altheimat- licher Tracht.**

e der „Deutschen Tag Vereinigung" Die deutschen Sänger Chicagos stimm-

D

Als i schaft damalig unerträ Kolonis lästige Jahr sp dem Z keitserk Tag zur Geschic

In d keitserk **die Gru alle Me Schöpfe Rechter Leben, Glück** aller erklärü **fünfund** ses, im Bevölke unterze den W **dieser auf die** ten wi Leben, heiligen

Auch terzeich erklärü dern ei mit ihr Gerech die Ver gen. Si ken der rechtlic

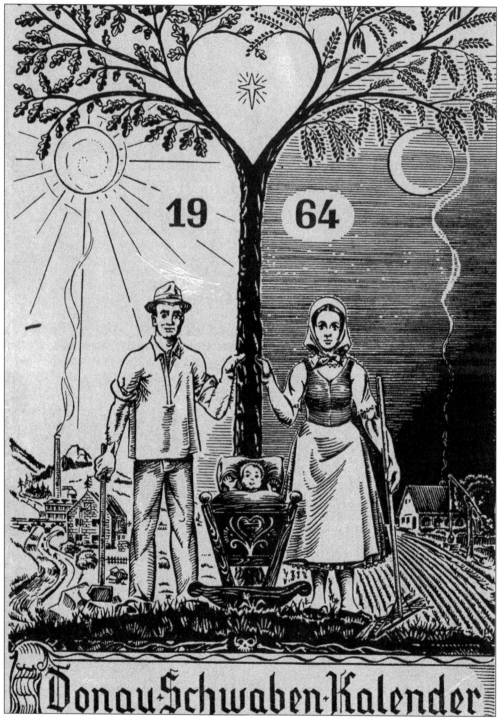

DONAUSCHWABEN KALENDER, 1964. Just 20 years after World War II, it is easy to see the Danube Swabian's most important values represented in this cover drawing. I have placed this periodical, 1964–1996, into UIC's Special Collections, courtesy of Nikolaus Krieling. (Photograph taken from *Donauschwaben Kalender*.)

DR. HAROLD WELSCH, 1999. He is a Professor of Management at DePaul University and is Annerose's little brother. (Photographs courtesy of Annerose Görge.)

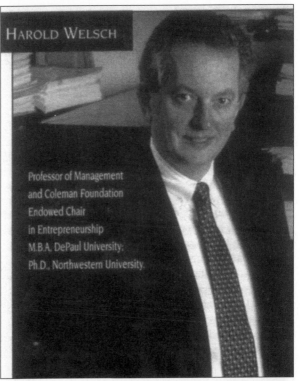

HAROLD WELSCH

Professor of Management
and Coleman Foundation
Endowed Chair
in Entrepreneurship
M.B.A. DePaul University;
Ph.D., Northwestern University.

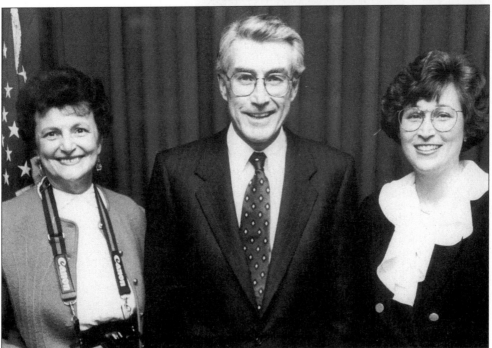

ANNEROSE GÖRGE AND HER DAUGHTER, DORIS O'NEILL, WITH ILLINOIS GOVERNOR JIM EDGAR, AFTER DORIS'S APPOINTMENT TO THE REGULATION BOARD OF SOCIAL WORKERS. She earned her master's in Social Work from Loyola University.

DR. ROBERT M. GÖRGE, ABOVE, ASSISTANT DIRECTOR, CHAPIN HALL CENTER FOR CHILDREN AT THE UNIVERSITY OF CHICAGO.

HORST GÖRGE WITH TALIA GÖRGE, HIS GRANDDAUGHTER. (Photographs courtesy of Annerose Geörge.)

HORST AND ANNEROSE GÖRGE, CHICAGO 1999. (Photograph courtesy of Annerose Geörge.)

Five

GERMAN MUSIC IN CHICAGO

There is a rich variety of German musical and singing groups in the City of Big Shoulders, as this chapter hopes to demonstrate. Because of space limits, it was necessary to combine the different groups, and to present them this way, in collage. Much of the research I present here came from my *Doktorvater* Charles M. Barber's archives.

CHARLES AND VIRGINIA BARBER. Here the two teachers enjoy a moment together before Charlie goes back to sing with the Rheinischer Gesang Verein, Christmas 1999, at the DANK Haus, Chicago, IL. (Photograph courtesy of Raymond Lohne.)

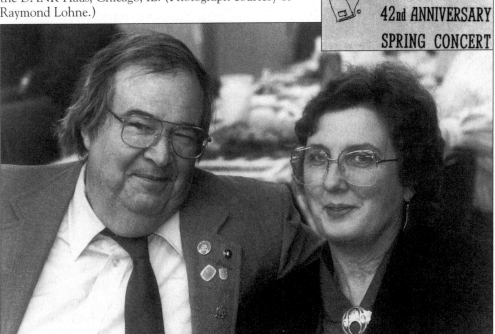

42nd ANNIVERSARY SPRING CONCERT

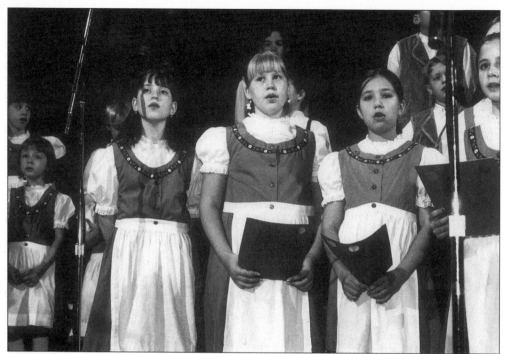

WEIHNACHTSKONZERT, IRISH-AMERICAN HERITAGE CENTER, 4626 N. KNOX AVE, CHICAGO, DECEMBER 12, 1999. (Photograph courtesy of Raymond Lohne.)

CAROL HIMMEL AND MARION KRAJECKE, DECEMBER 1999. Himmel is the Director of the Kinder Choir and Krajecke is her assistant. (Photograph courtesy of Raymond Lohne.)

WEINACHTSKONZERT, DECEMBER 12, 1999. (Photograph courtesy of Raymond Lohne.)

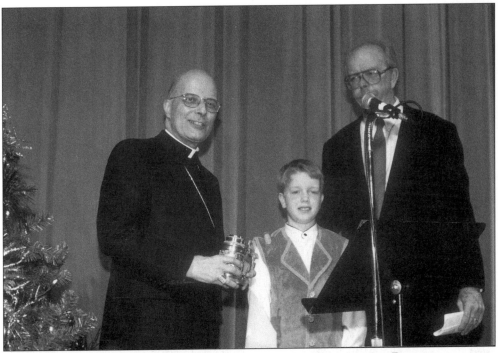

CARDINAL GEORGE, A YOUNG SINGER, AND DWIGHT VON AHNEN, PRESIDENT OF THE GERMAN-AMERICAN KINDERCHOR, AT THE WEIHNACHTSKONZERT, DECEMBER 12, 1999. (Photograph courtesy of Raymond Lohne.)

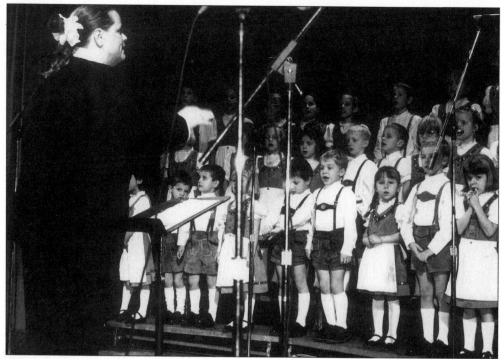

CAROL HIMMEL, WEIHNACHTSKONZERT, DECEMBER 12, 1999. Here she is leading the children in song. (Photograph courtesy of Raymond Lohne.)

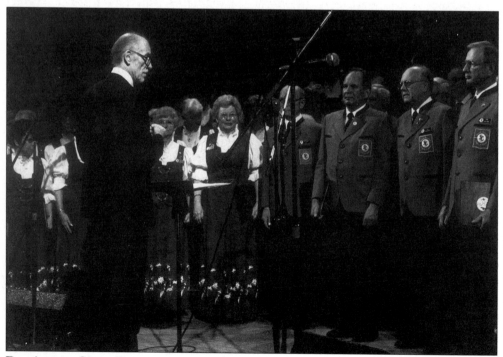

DR. ALFRED GRAS, DECEMBER 1999. The esteemed director prepares to lead the German-American Singers. (Photograph courtesy of Raymond Lohne.)

PROF. DR. FRANK MUELLER, UNIVERSITY
OF WISCONSIN-PARKSIDE, AND DIRECTOR
OF THE RHEINISCHER GESANG VEREIN, C.
1972. (Photograph courtesy of Charles M.
Barber.)

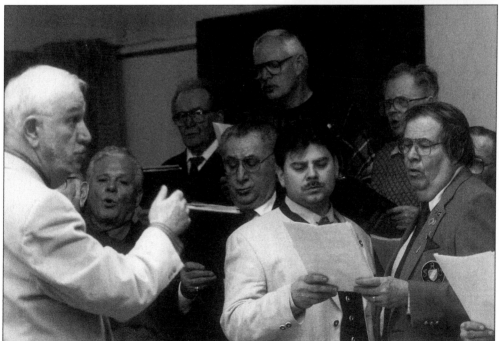

DR. MUELLER LEADING THE GROUP, CHRISTMAS 1999, AT THE DANK HAUS IN CHICAGO.
Charlie Barber—my mentor at Northeastern Illinois University—is at right. (Photograph
courtesy of Raymond Lohne.)

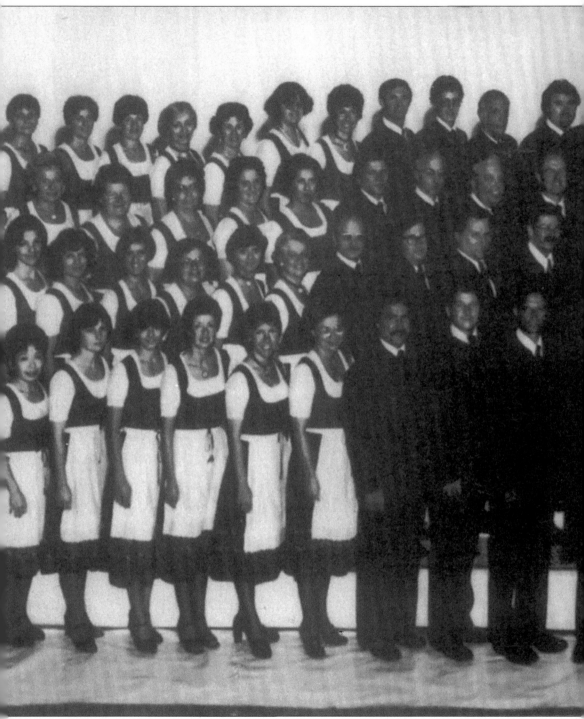

GERMAN-AMERICAN SINGERS, CHICAGO 1981. (Photograph courtesy of Charles M. Barber.)

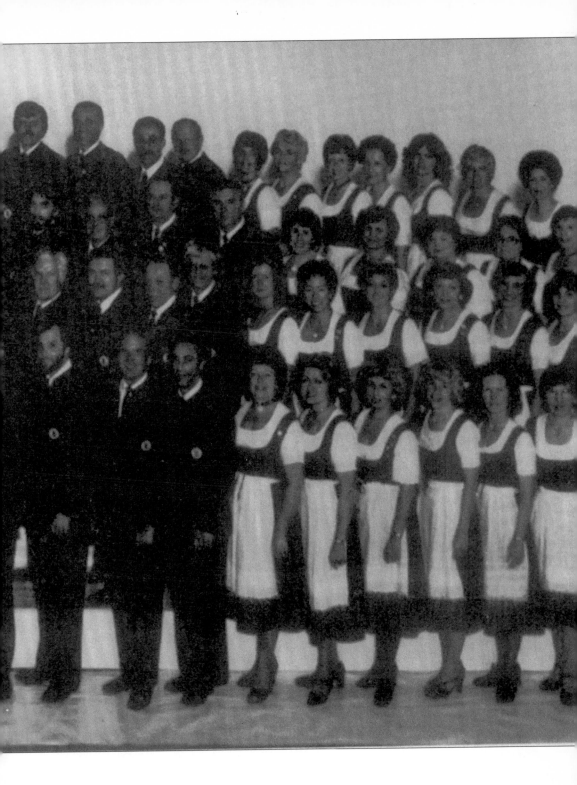

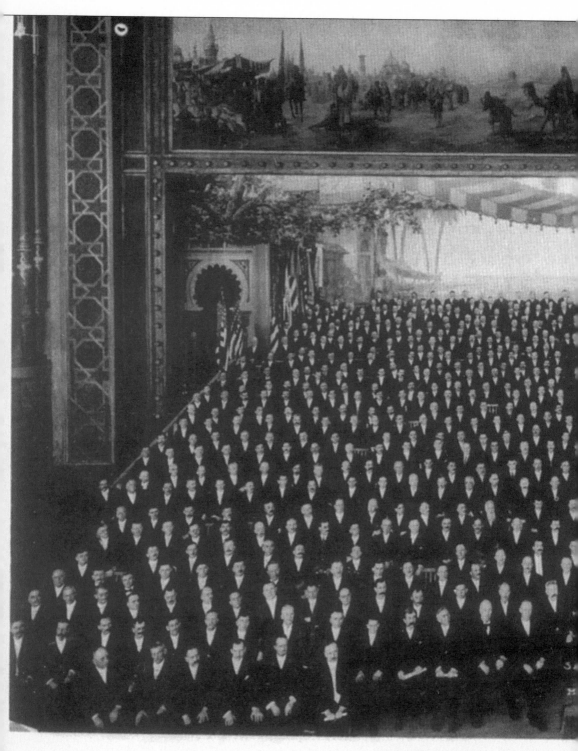

VEREINIGTE MAENN

THE UNITED MALE CHOIRS OF CHICAGO, APRIL 3, 1921, IN THE MEDINAH TEMPLE.

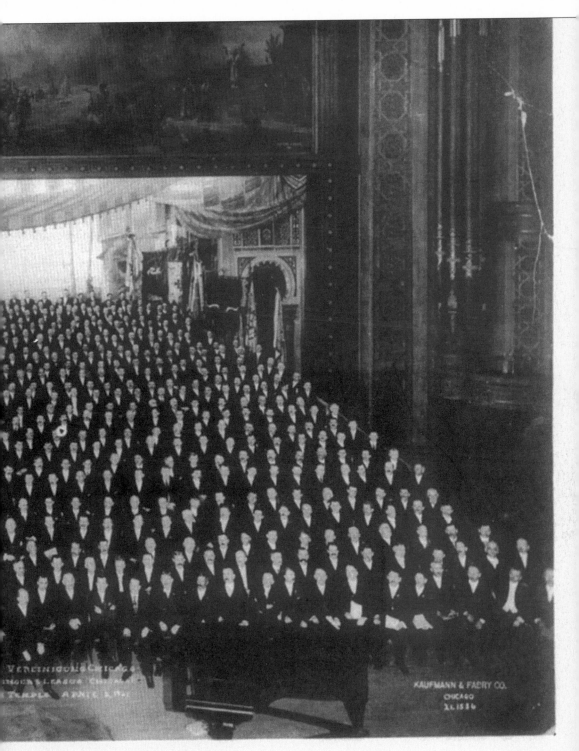

CHOERE VON CHICAGO

(Photograph courtesy of Charles M. Barber.)

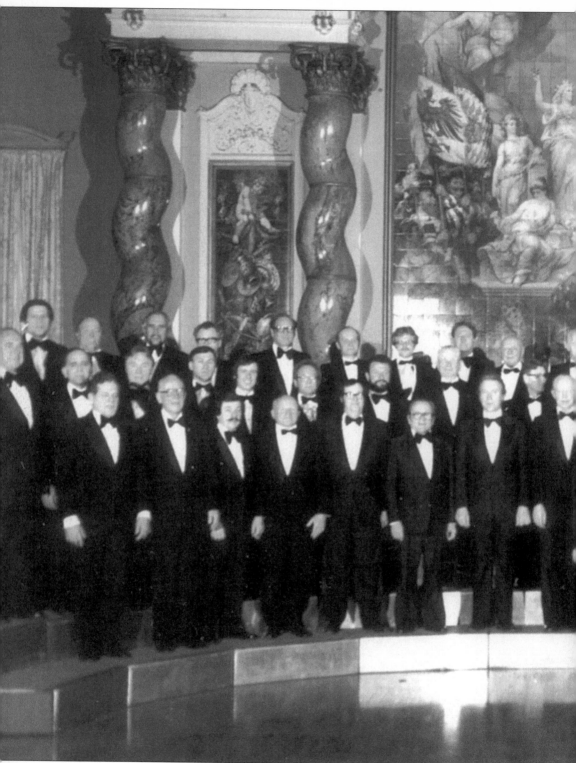

RHEINISCHER GESANG VEREIN, GERMANIA CLUB, CHICAGO. (Photograph courtesy of Charles

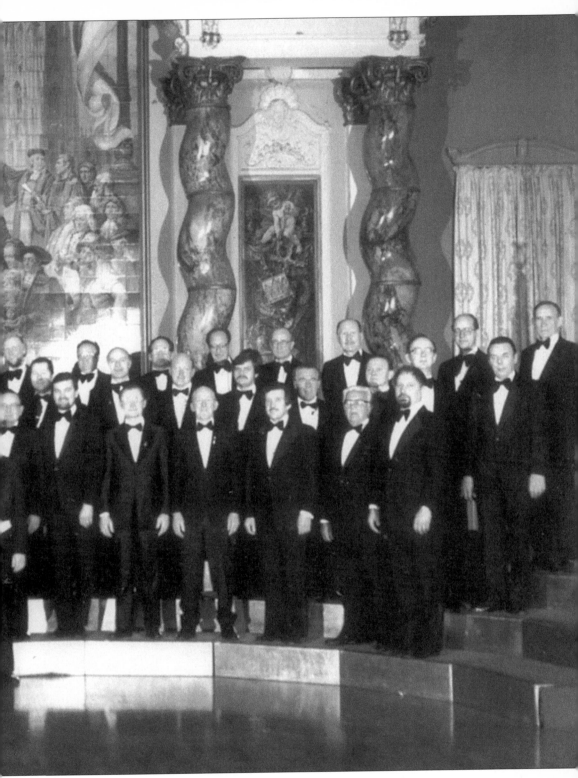

M. Barber.)

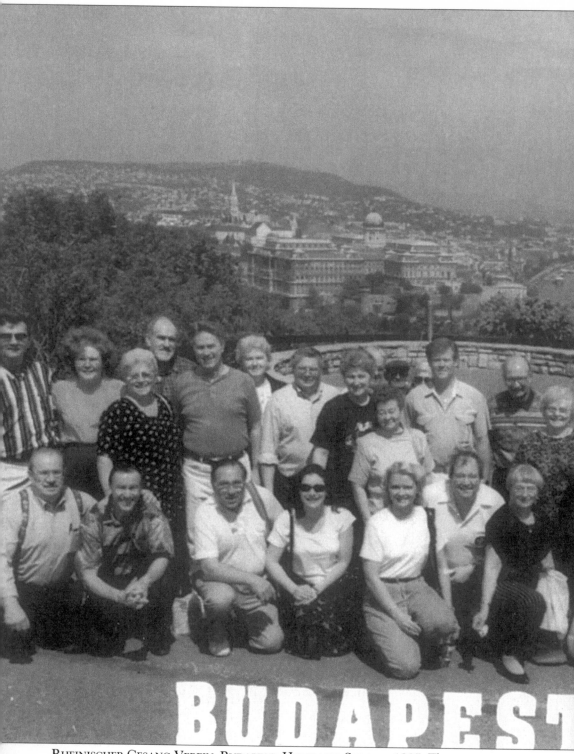

RHEINISCHER GESANG VEREIN, BUDAPEST, HUNGARY, SUMMER 1997. The group was on tour following its appearance at the International Schubert Chorfest in Vienna, May 8–11, 1997.

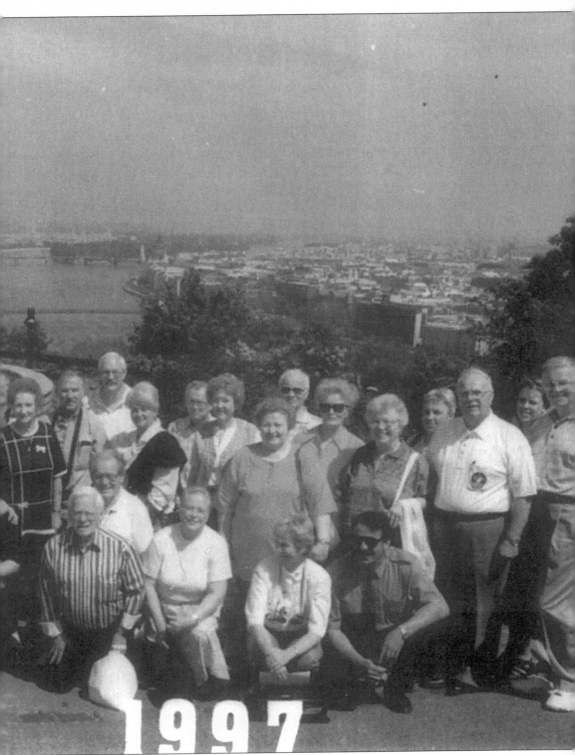

(Photograph courtesy of Charles M. Barber.)

-Benefit Concert-

for the

German-American Old Peoples Home
Forest Park

Presented by

RHEINISCHER GESANG VEREIN

Accompanied by

German-American Senior Chorus

Under the Direction of

Professor Dr. Alfred Gras

ADVERTISEMENT FOR THE RHEINISCHER GESANG VEREIN, CHICAGO 1976. (Photograph courtesy of Charles M. Barber.)

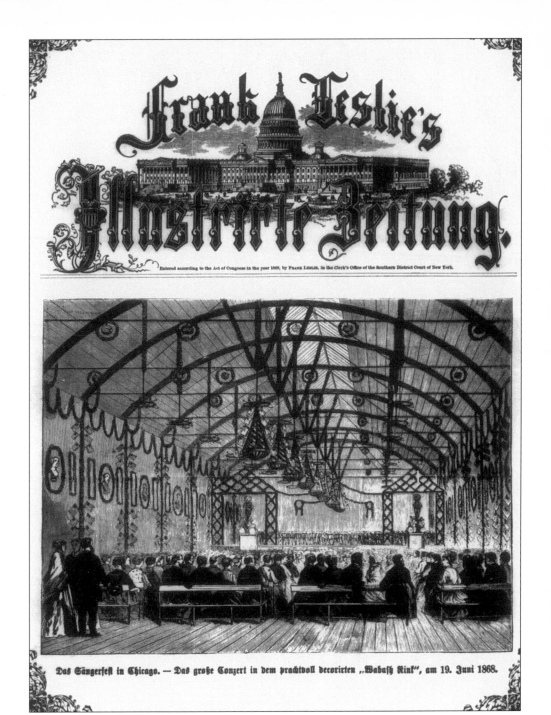

Das Sängerfest in Chicago. — Das große Conzert in dem prachtvoll decorirten „Wabash Rink", am 19. Juni 1868.

FRANK LESLIE'S *ILLUSTRIERTE ZEITUNG*, OF JUNE 19, 1868, DESCRIBING THE SINGER FEST IN CHICAGO THAT SUMMER. (Photograph courtesy of Charles M. Barber.)

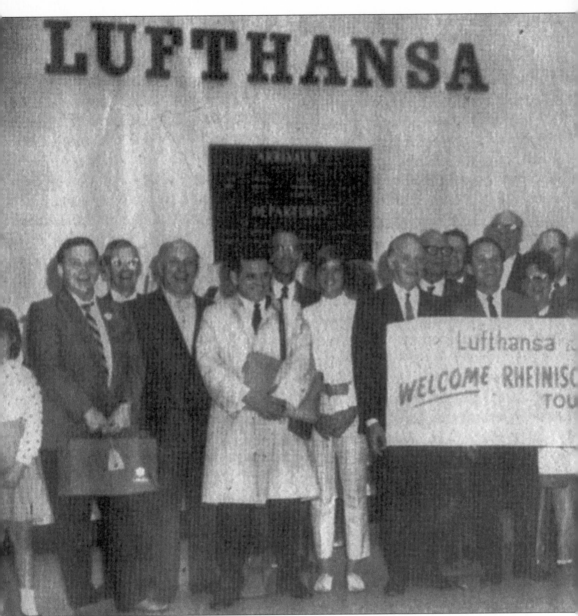

CHICAGO. The Rheinischer Gesang Verein gets ready to leave for Germany, June 27, 1968.

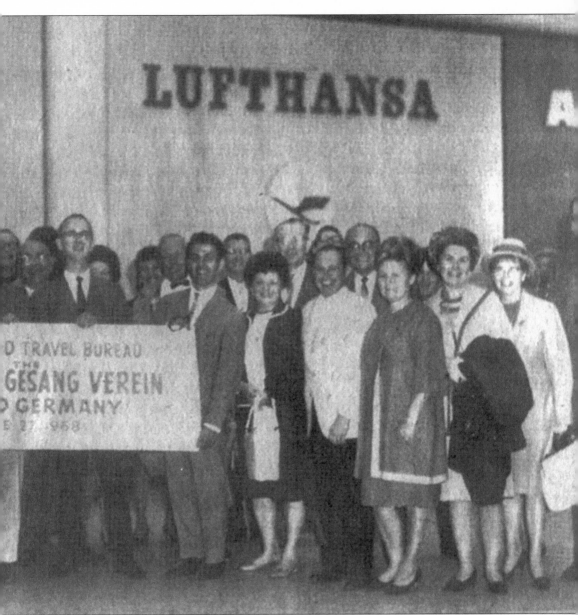

(Photograph courtesy of the Eintracht.)

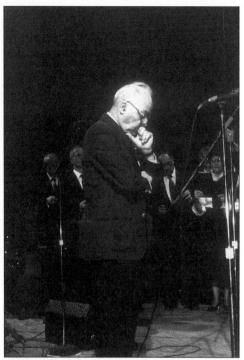

ALFRED SCHOEPKO, DIRECTING AT THE WEINACHTSKONZERT, DECEMBER 12, 1999. (Photograph courtesy of Raymond Lohne.)

WEIHNACHTSKONZERT KINDER, DECEMBER 12, 1999. (Photograph courtesy of Raymond Lohne.)

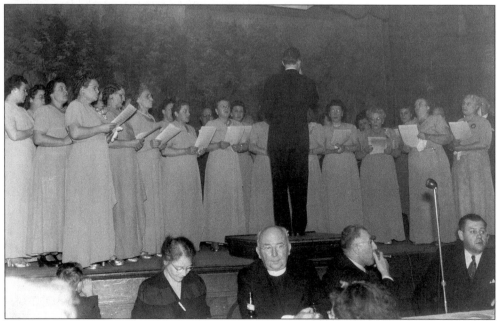

AMERICAN AID SOCIETY, LOGAN SQUARE MASONIC TEMPLE, C. 1951. The ladies of an unidentified German choir entertain at the annual banquet of the A.A.S. John Meiszner is seated at the extreme right. (Photograph courtesy of the Meiszner family.)

Six

DANK, CHICAGO

As the name implies, The *Deutsch Amerikanischer National Kongress*, or DANK, is a social-political organization which has the interests of their ethnic group in mind. DANK also means "thanks" and represents exactly how most German Americans feel about America. This organization's logo claims they are "The Voice of German-Americans From Coast to Coast." That would translate into almost 58 million people, according to the 1990 U.S. Census. Yet today, DANK, as an organization, wonders where they all are. This is the entrance to the DANK Haus in Lincoln Square, Chicago. (Photograph courtesy of DANK.)

ALFRED MAURICE DE ZAYAS. Here shown in the newspaper *DeutschAmerikaner*, 1974. Today De Zayas is widely recognized in Europe and in the German-American community as the premier historian of the Expulsion as seen from the German side. DeZayas earned his J.D. from Harvard and then went on to earn a Ph.D. in History from Göttingen.

He is the Senior Human Rights Officer at the U.N. in Geneva, Switzerland, and President of the United Nations Staff Society of Writers, where his poetry is regularly published in *Ex Tempore*. (Photograph courtesy of DANK, Chicago.)

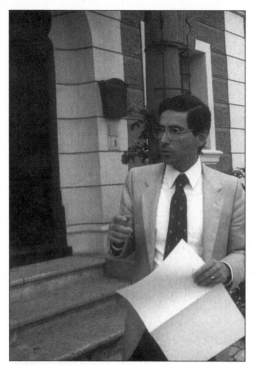
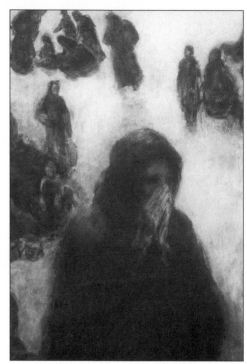

ALFRED DE ZAYAS, ABOVE, GENEVA, SWITZERLAND. BELOW: NOVEMBER 16, 2000. PROF. DR. DEZAYAS WITH RAYMOND LOHNE, LT. GENERAL MICHAEL HAYDEN, HIS WIFE AND DR. MARIANNE BOUVIER AT DUQUESNE UNIVERSITY'S CONFERENCE ON ETHNIC CLEANSING IN TWENTIETH CENTURY EUROPE. De Zayas was among the first American scholars to tackle the German side of the story, in *The Wehrmacht War Crimes Bureau,* and the first to feature a tremendous Susanna Tschurtz painting on the cover of *A Terrible Revenge: The Ethnic Cleansing of the East European Germans, 1944–1950.* With that collaborative act, the professor and the painter confirmed what millions of people today vividly remember. (Photographs courtesy of Alfred De Zayas, Susanna Tschurtz and Raymond Lohne.)

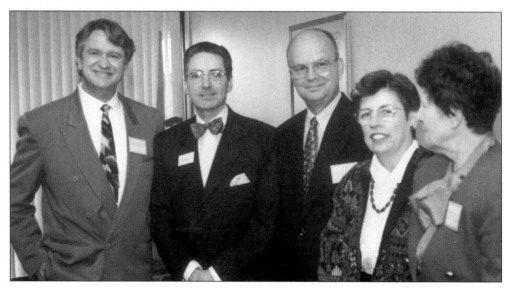

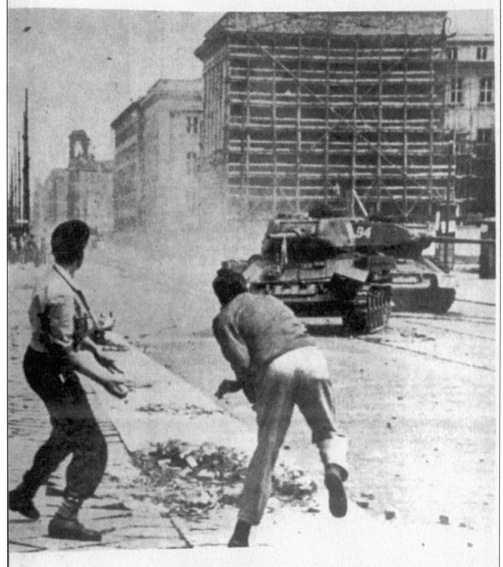

DER DEUTSCHAMERIKANER, JUNE 1972. A full-page remembrance of the uprising in Berlin, June 19, 1953. (Photograph courtesy of D.A.N.K.)

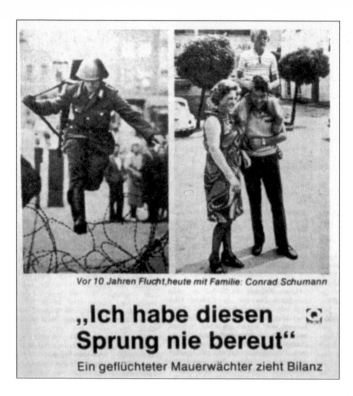

Vor 10 Jahren Flucht, heute mit Familie: Conrad Schumann

„Ich habe diesen Sprung nie bereut"

Ein geflüchteter Mauerwächter zieht Bilanz

DER DEUTSCHAMERIKANER, JUNE, 1972. An East German soldier leaps to freedom in the West. The caption reads, "I have never regretted that jump." (Photograph courtesy of D.A.N.K.)

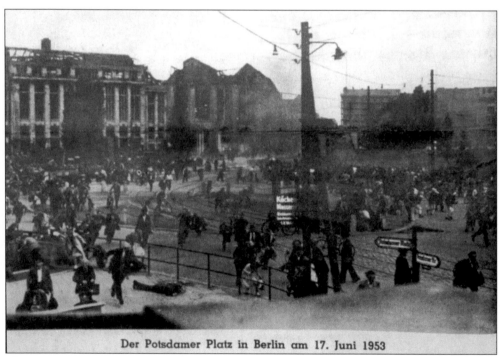

Der Potsdamer Platz in Berlin am 17. Juni 1953

DER DEUTSCHAMERIKANER, JUNE 1972. This photograph depicts the riot in Berlin's Potsdamer Platz, June 17, 1953. (Photograph courtesy of D.A.N.K.)

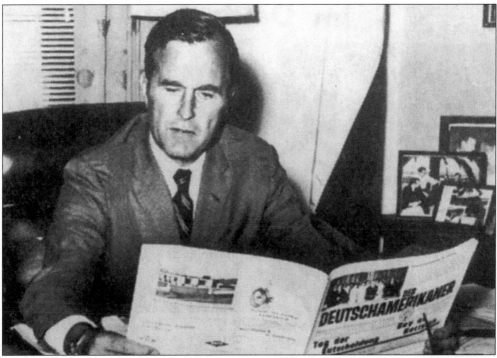

Congressman George Bush, Washington D.C., Reading *Der Deutschamerikaner*. (Photograph courtesy of D.A.N.K.)

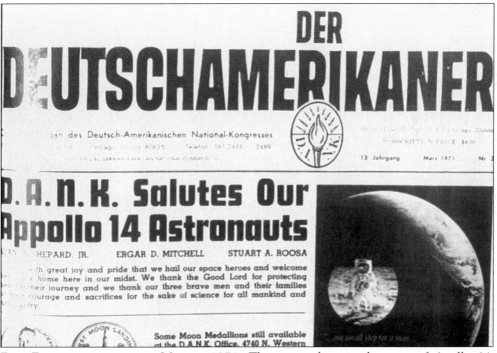

Der Deutschamerikaner, March 1971. This is a salute to the crew of Apollo 14. (Photograph courtesy of D.A.N.K.)

Captive Nations Week Observance in Chicago

The Chicago Captive Nations Committee participated in the observance of the 13th annual Captive Nations Week, July 17-22. "Captive Nations Week" was authorized by a joint resolution of Congress on July 17th, 1959, Public Law (86-90), which authorized and requested President Dwight D. Eisenhower to issue a Proclamation designating the third week in July as "Captive Nations Week", and to issue a Proclamation each year until such time when freedom and independence shall have been achieved for all the captive nations.

Presently, the 28 national groups composing the Captive Nations are: Armenia, Azerbaijan, Bielarus, Georgia, Idel-Ural, North Caucasia, Ukraine, Turkistan, Mongolia, Estonia, Latvia, Lithuania, Albania, Bulgaria, Serbia, Slovakia, Croatia, Slovenia, Poland, Rumania, Czechoslovakia, North Korea, Hungary, Central Germany, China, Tibet, North Vietnam, Cuba and others.

The observance featured a parade by members of the national groups, wearing their native costumes, joined by city officials, Chicago civic and business leaders, on State Street. Following the parade a luncheon was held at the Conrad Hilton Hotel. Many dignitaries attended and spoke at this luncheon.

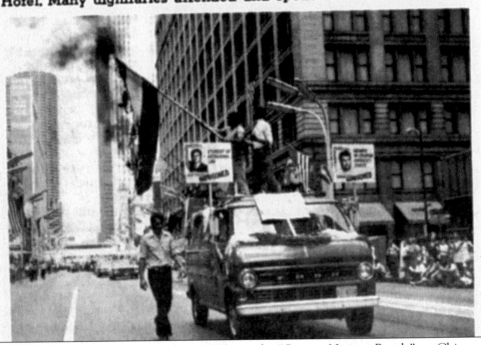

DER DEUTSCHAMERIKANER, JUNE 1972. This is the "Captive Nations Parade" on Chicago's State Street. (Photograph courtesy of D.A.N.K.)

RICHARD J. DALEY, 1972. Here is an ad which ran courtesy of the Democratic Committee of DANK, with Kurt von Besser as chairman.

Richard J. Daley

A Great Mayor . .
. . For a Great City

MAYOR DALEY ACCEPTS A BEER STEIN FROM MISS DANK IN CHICAGO. (Photographs courtesy of DANK, Chicago.)

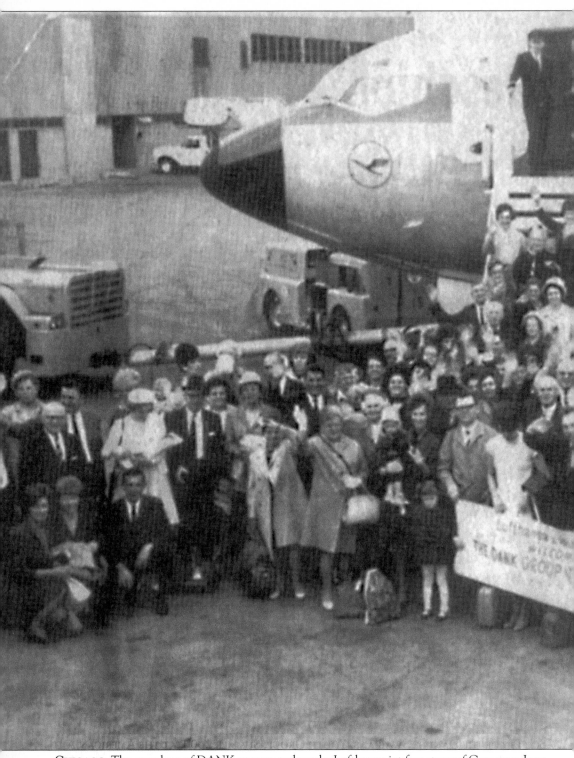

CHICAGO. The members of DANK prepare to board a Lufthansa jet for a tour of Germany, June

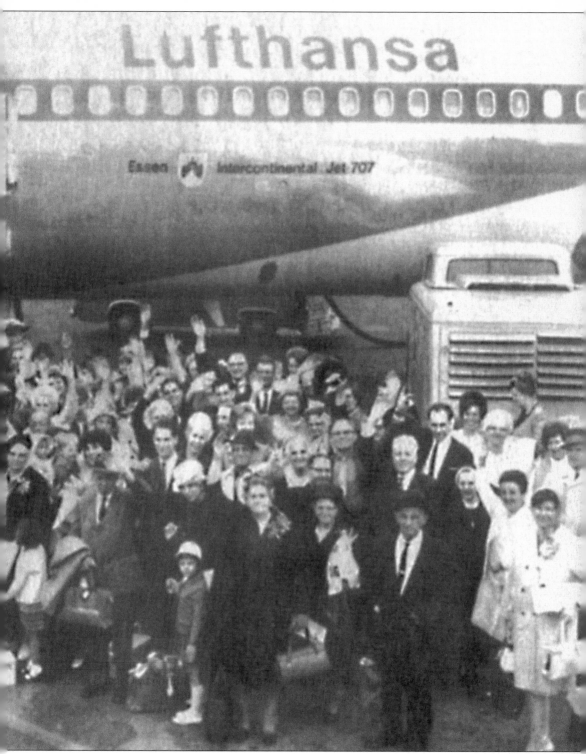

1968. (Photograph courtesy of the Eintracht.)

DANK Logo. Taken from a pamphlet. (Photograph courtesy of D.A.N.K, Chicago.)

Seven

THE *EINTRACHT* GERMAN WEEKLY

The *Eintracht* German weekly was started by Jacob Himplemann in 1922 as a "German Austrian Hungarian" paper. The name literally means "harmony" (which is probably evidence of the divisive diversity of the German community in Chicago at that time as well). That hadn't changed when the Juengling family acquired the paper in 1958. Gottlieb Juengling was a school teacher who had experience as a sports reporter with the *Ludwigsburger Kreiszeitung* in Germany. His sons, Walter

and Klaus took over the entire operation in 1978. Walter was in the carpentry department of the *Chicago Sun Times* for 17 years, and Klaus served as a part-time reporter at least 10 years before their father's death. It has a circulation at the time of this writing of over 25,000.

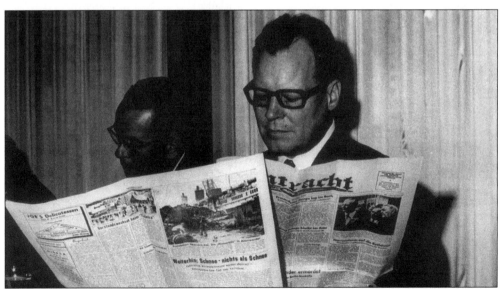

WILLY BRANDT, THE MAYOR OF BERLIN, READS THE *EINTRACHT*, C. 1962. (Photograph courtesy of the *Eintracht*.)

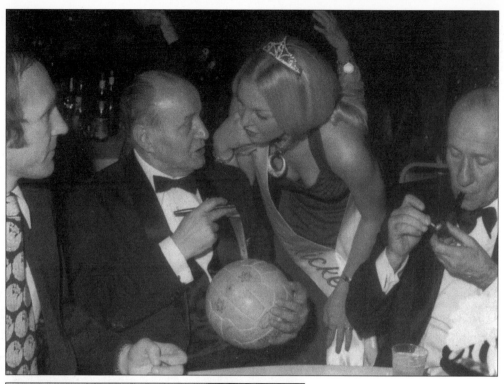

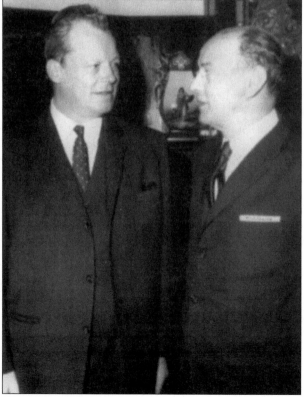

GOTTLIEB JUENGLING, CHICAGO, 1968. He is the man who bought the *Eintracht* from Jacob Himplemann. Here he signs a soccer ball for Miss Illinois while Germany's national soccer star Willy Schultz looks on (left), and Germany's national soccer coach, Helmut Schoen lights his pipe. (Photograph courtesy of the *Eintracht*.)

WILLY BRANDT AND GOTTLIEB JUENGLING. The newspaperman meets the Chancellor of Germany. (Photograph courtesy of the *Eintracht*.)

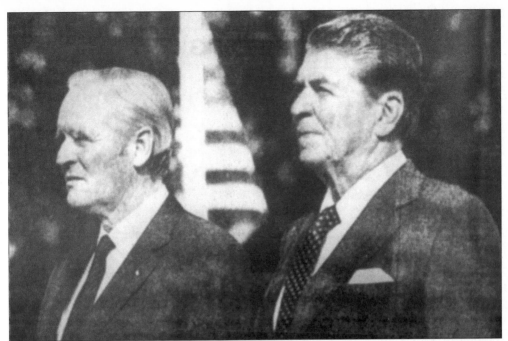

***EINTRACHT*, OCTOBER 5, 1983**. The President of The Federal Republic of Germany, Karl Carstens, with President Ronald Reagan in the White House Rose Garden. (Photograph courtesy of the *Eintracht*).

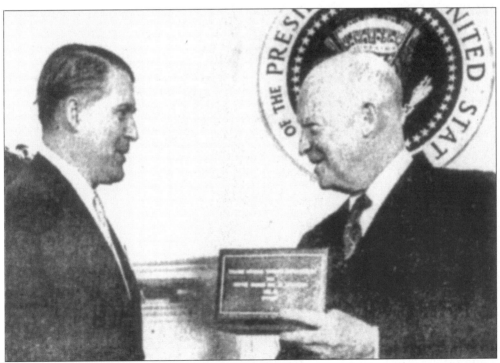

***EINTRACHT*, OCTOBER 5, 1983**. The caption reads "Two notorious Americans with German blood: Dwight D. Eisenhower and Werner von Braun." (Photograph courtesy of the *Eintracht*.)

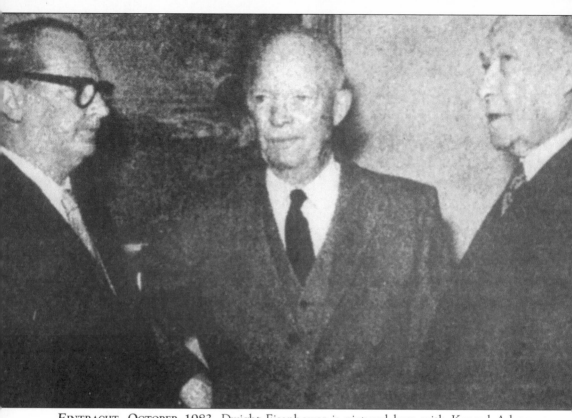

***Eintracht*, October 1983**. Dwight Eisenhower is pictured here with Konrad Adenauer. (Photograph courtesy of the *Eintracht*.)

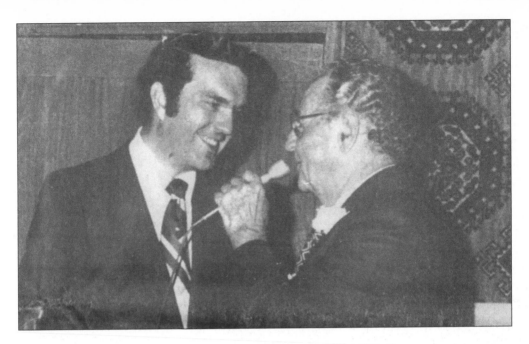

LUDWIG LOHMILLER, AUGUST 1978. Aldermann Eugene Schulter brings the mayor's greetings to Lohmiller during the 50th anniversary celebration of his being a music director. (Photograph courtesy of the *Eintracht*.)

300 Jahre Deutsch-Amerikaner

150 Jahre Stadt Chicago und

50

Im Spaetsommer des Jahres 1978 feierte der deutsch-amerikanische Dirigent Ludwig Lohmiller sein 50.Dirigentenjubilaeum. Unsere damalige Mitarbeiterin Eleanor F.Weers schrieb darueber einen Bericht, den wir hier zur Erinnerung an Ludwig Lohmillers aktive Jahre um die Erhaltung und Pflege

Chi
sich
Worte
Banke
Sonnt
Schwa
sen Pr
eine K
Ein
phaer
Platz
hunde
nen u
eingef
Gesch
der 50
Deuts
in Chi
um ih
golden
Tafel
Gattin
bische
mit G
der V
Chica
vom D
ard Ad
in Chi
der D

EINTRACHT FAMILY. Marianne and Walter Juengling, with their children, (left to right) Gisela Juengling-Brandt, Ursula Juengling-Kolb, Renate Juengling, and Walter Jr. (Photograph courtesy of the Juengling family.)

EINTRACHT FAMILY. Klaus and Isle Juengling (with Christian), and their children (left to right) Barbara and Don Schultz, Craig and Susan Ligda, and Debbie Lazzara. (Photograph courtesy of the Juengling family.)

THE GRAND DAME OF THE *EINTRACHT*, EMMY JUENGLING WITH WALTER AT HER 85TH BIRTHDAY PARTY. (Photograph courtesy of the Juengling family.)

KLAUS JUENGLING. Here he covers the grand opening of the American Aid Society's new Cultural Center in October 1999. (Photograph courtesy of Raymond Lohne.)

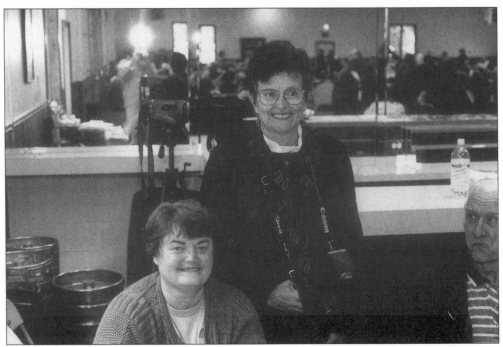

ANNEROSE GEÖRGE, STANDING, WITH ELSA WALTER, FALL 2000. She is a reporter and layout designer for the *Eintracht*. (Photograph courtesy of Raymond Lohne.)

ELSA AND MIKE WALTER, KIRCHWEIHE 1999. From time to time I make contributions to the *Eintracht*, in fact, they serialized my first book, *The Great Chicago Refugee Rescue*. Here is a photo I shot for the newspaper.

Eight
THE GERMAN AMERICAN WOMAN

One of my minor fields at UIC is Women's History. Dr. Eric Arnesen first introduced me to Hull House and the work of Jane Addams, and encouraged me to pursue this field. With Dr. Susan Levine I have begun to explore Women's History in greater depth. This chapter represents a brief look at but a few of Chicago's noteworthy German-American women.

KARINA HOPP, RIGHT, AT THE GRAND OPENING OF THE AMERICAN AID SOCIETY'S NEW CULTURAL CENTER. (Photograph courtesy of Raymond Lohne.)

SUSANNA TSCHURTZ. Here the unknown artist appears in a 1972 *Chicago Sun Times* article about Oktoberfest. The article mentioned Robert, her husband, but not her. (Photograph courtesy of Susanna Tschurtz.)

started chef Robert Tschurtz (center) had the sausage-cooking operation under control. As soon as he got the sausages on the stove, waitresses loaded trays with huge German pretzels.

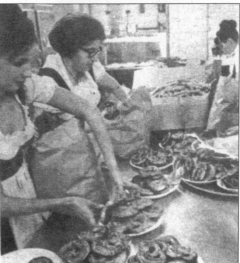

AMERICAN AID SOCIETY, C. 1952. Some of the young women who immigrated to Chicago

under the Displaced Persons Act of 1948. (Photograph courtesy of the American Aid Society.)

ELIZABETH GEBAVI, SUMMER 1999. Her husband is always in the German-American newspaper, but Elizabeth is also one of the hardest workers for the American Aid Society. She is the museum curator. Here she is caught in a rare moment of relaxation. (Photograph courtesy of Raymond Lohne.)

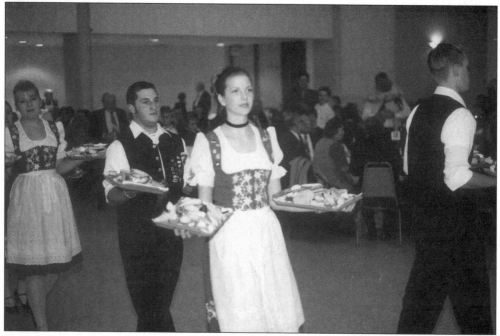

KARINA HOPP, CHICAGO, 1999. Here she is, hard at work as a waitress for the American Aid Society Kirchweihe in the St. Demetrious Hall. (Photograph courtesy of Raymond Lohne.)

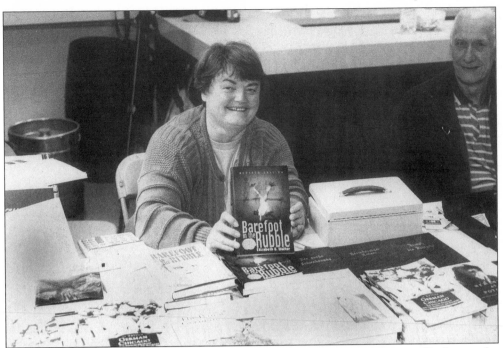

ELSA WALTER, 2000. Here she is selling her book at the American Aid Society. She has single-handedly sold over 20,000 copies. (Photograph courtesy of Raymond Lohne.)

ELSA WALTER, 1999. Elsa is the dedicated leader of the children's group, a position she has occupied for many years. (Photograph courtesy of Raymond Lohne.)

IRENE ROTTER, CHICAGO, 1999. Here she is at St. Demetrious Hall with Judy Baar-Topinka, the State Treasurer of Illinois. Though she has worked at a market for nearly 30 years, she still manages to attend every important German-American function in Chicago. (Photograph courtesy of Raymond Lohne.)

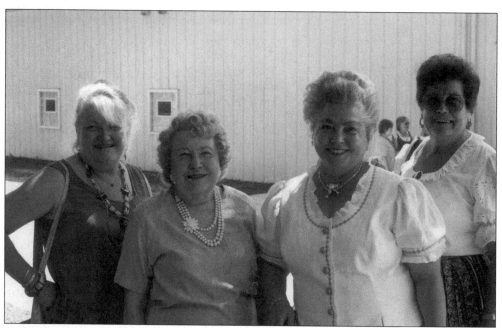

HELEN AND JOYCE MEISZNER, SUMMER 1999. The Meiszner Funeral Home is run by the Meiszner women, and has been since before John Meiszner's death. Here the matriarch and her daughter, left, are photographed with Irene Rotter and Margaret Gunther. (Photograph courtesy of Raymond Lohne.)

HERMINE HAUSNER, RIGHT, WITH HUSBAND KARL, AND MARTHA KENT, NOVEMBER 18, 2000, PITTSBURGH, PA. Mrs. Hausner is literally her husband's right-hand man, because he is blind. He contracted an eye infection in a coal mine as a slave after World War II, which went untreated and eventually cost him his sight. An engineer in the medical field, he owns Elmed Incorporated in Addison, IL. (Photograph courtesy of Raymond Lohne.)

RHEINISCHER GESANG VEREIN, DANK HAUS, CHRISTMAS 1999. (Photograph courtesy of Raymond Lohne.)

KATHERINE GLASENHARDT, SEATED, SUMMER 2000. As I said, she has my vote for the hardest-working woman I ever met. (Photograph courtesy of Raymond Lohne.)

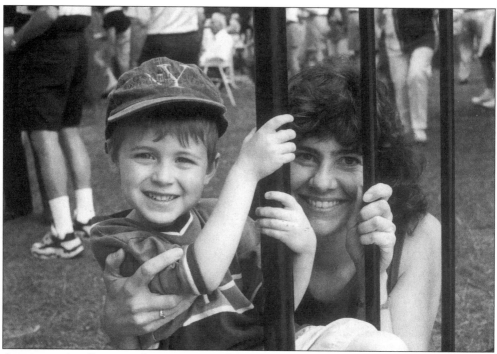

AMERICAN AID SOCIETY, SUMMER 2000. (Photograph courtesy of Raymond Lohne.)

RHEINISCHER GESANG VEREIN, DANK HAUS, CHICAGO, CHRISTMAS 1999. (Photograph courtesy of Raymond Lohne.)

SOCIETY OF THE DANUBE SWABIANS, C. 1972. (Photograph courtesy of the Verein der Donauschwaben.)

RHEINISCHER GESANG VEREIN, DANK HAUS, CHICAGO, CHRISTMAS 1999. (Photograph courtesy of Raymond Lohne.)

RHEINISCHER GESANG VEREIN, DANK HAUS, CHICAGO, CHRISTMAS 1999. (Photograph courtesy of Raymond Lohne.)

RHEINISCHER GESANG VEREIN, DANK HAUS, CHICAGO, CHRISTMAS 1999. (Photograph courtesy of Raymond Lohne.)

AMERICAN AID SOCIETY, SUMMER 2000. (Photograph courtesy of Raymond Lohne.)

AMERICAN AID SOCIETY, SUMMER, 1999. LAKE VILLA, IL. (Photograph courtesy of Raymond Lohne.)

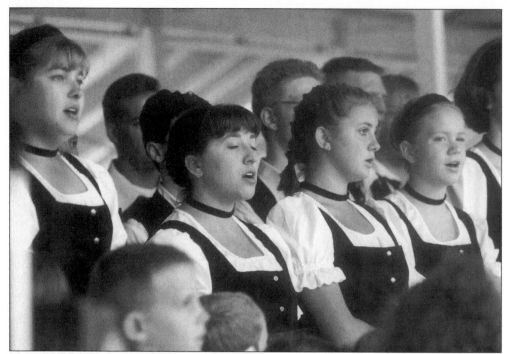

AMERICAN AID SOCIETY, SUMMER 2000. (Photograph courtesy of Raymond Lohne.)

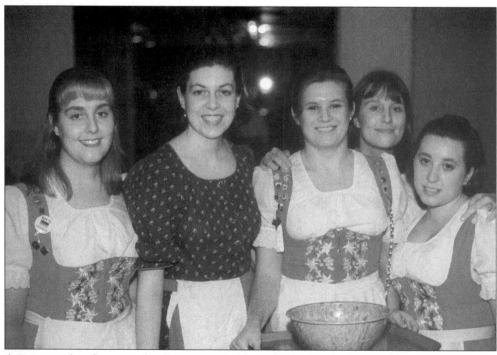

AMERICAN AID SOCIETY, ST. DEMETRIOUS HALL, KIRCHWEIHE 1998. (Photograph courtesy of Raymond Lohne.)

AMERICAN AID SOCIETY, RIGHT, SUMMER 2000. A lot of hard work goes on behind the scenes at most German-American affairs. (Photographs courtesy of Raymond Lohne.)

ST. DEMETRIOUS HALL, KIRCHWEIHE, 1998.

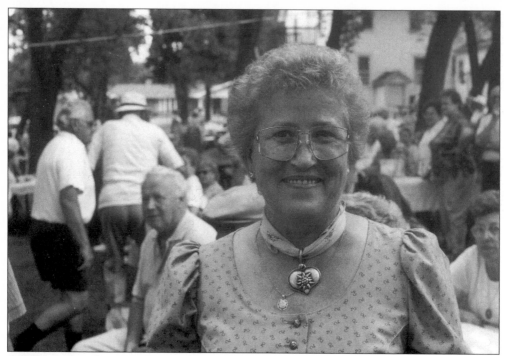

AMERICAN AID SOCIETY, SUMMER 2000. (Photograph courtesy of Raymond Lohne.)

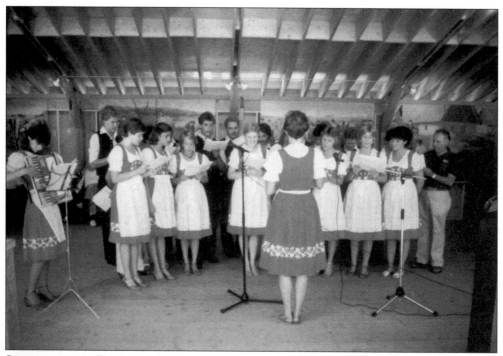

SOCIETY OF THE DANUBE SWABIANS, AMERICAN AID SOCIETY PICNIC GROUNDS, C. 1972. (Photograph courtesy of the Society of the Danube Swabians.)

AMERICAN AID SOCIETY, KIRCHWEIHE 1999. (Photograph courtesy of Raymond Lohne.)

AMERICAN AID SOCIETY, KIRCHWEIHE 1998. (Photograph courtesy of Raymond Lohne.)

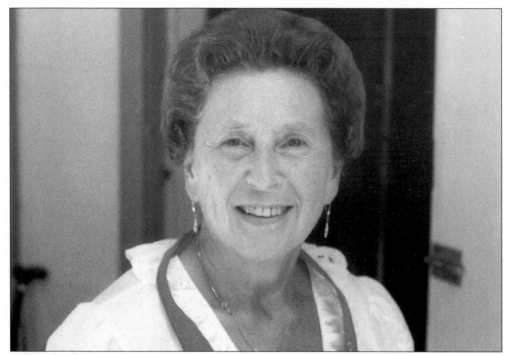

AMERICAN AID SOCIETY, SUMMER 1998. (Photograph courtesy of Raymond Lohne.)

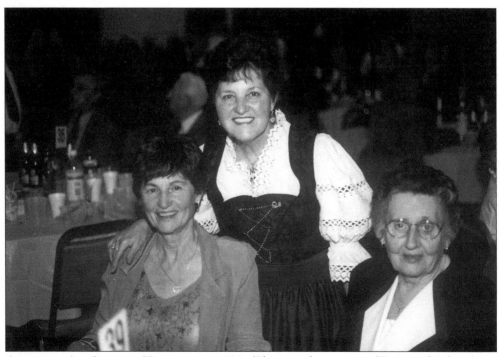

AMERICAN AID SOCIETY, KIRCHWEIHE 1999. (Photograph courtesy of Raymond Lohne.)

PHOTOGRAPHIC
ACKNOWLEDGEMENTS

MRS. JAINZ, FRANKFURT AM MAIN, RIGHT, WITH HER BEST FRIEND, C. 1977. She is my maternal grandmother. (Photograph courtesy of Marianna and Ted Moreland.)

MY FIRST BOOK WITH ARCADIA.

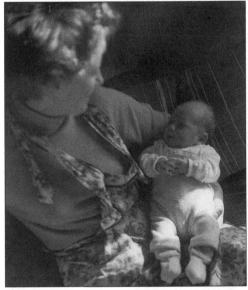

MARIANNA JAINZ WITH AUTHOR, FRANKFURT AM MAIN, SUMMER 1956. (Photograph courtesy of Marianna and Ted Moreland.)

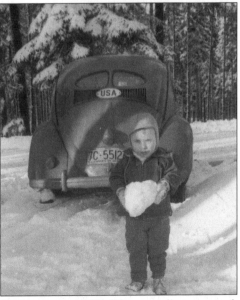

BAVARIA, C. 1958. (Photograph courtesy of Ortwin Lohne.)

SEIN UND ZEIT, FRANKFURT AM MAIN, 1958. (Photograph courtesy of Ortwin Lohne.)

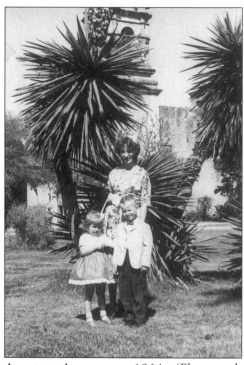

AT THE ALAMO, C. 1964. (Photograph courtesy of Ortwin Lohne.)

TANK HILL, FORT JACKSON, SOUTH CAROLINA, JANUARY 1973. (Photograph courtesy of Raymond Lohne.)

RAYMOND LOHNE WITH SARAH ARENA, *BELLA BAMBINA*, SUMMER 1997, WILMETTE, IL. We are at the home of her grandfather, John T. Miller, my father-in-law. He is one of those men in "The Greatest Generation." He won a Bronze Star on Okinawa as a Marine Corps lieutenant. He has become my mentor in many ways. She inspired the name of my company, Bella Bambina Productions, Inc.

NATALIA RAELYNN WRIGHT, ABOVE, MY GRANDDAUGHTER, AND NEWEST BELLA BAMBINA. (Top photograph courtesy of Francesco Arena Photography, Northbrook, Illinois. Above photograph courtesy of Anderson Photography, Round Lake Heights, Illinois.)

JOHN AND GWEN MILLER. In loving memory of Gwendolyn Morgan Miller. (Photograph courtesy of Raymond Lohne.)

MY SECOND BOOK "CONTRIBUTION" WITH ARCADIA PUBLISHING. (Photographs courtesy of Arcadia Publishing and Melvin Holli.)

DR. MELVIN G. HOLLI, RIGHT, UNIVERSITY OF ILLINOIS AT CHICAGO. Here is my advisor signing books in Borders Books, Chicago, for his *A View From City Hall: Mid-Century to Millennium*, published with Arcadia in 1999.

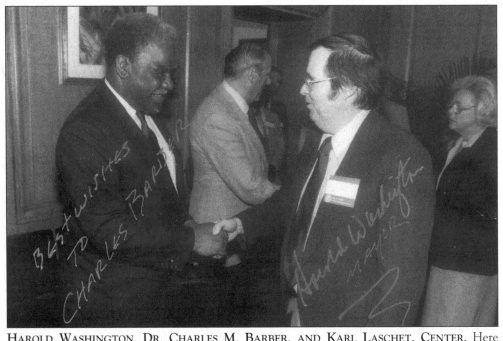

HAROLD WASHINGTON, DR. CHARLES M. BARBER, AND KARL LASCHET, CENTER. Here Washington is working the German-American vote in Chicago, 1985. (Photograph courtesy of Dr. Charles M. Barber.)

DR. SUSAN LEVINE. She is my minor professor in Women's History at UIC. (Photograph courtesy of Raymond Lohne.)

DR. ERIC ARNESEN. Here is my major professor in the March Against Racism, St. Louis, April 2, 2000, held during the Organization of American Historians Annual Conference. (Photograph courtesy of Raymond Lohne.)

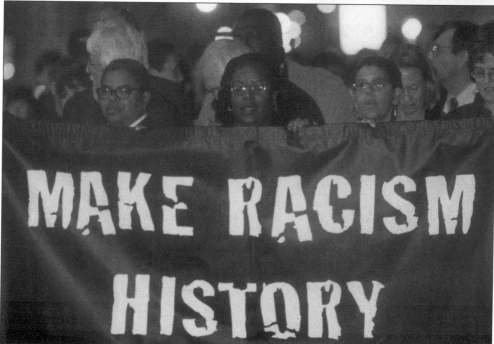

MAKE RACISM HISTORY, APRIL 2000, ST. LOUIS, MISSOURI. (Photograph courtesy of Raymond Lohne.)

DR. ROBERT MESSER, LEFT, AND DR. RICHARD LEVY, RIGHT, PROFESSORS OF HISTORY, UNIVERSITY OF ILLINOIS AT CHICAGO, JANUARY 2001. (Photographs courtesy of Raymond Lohne.)

JOHN M. CULLARS AND GRETCHEN LAGANA, UIC SPECIAL COLLECTIONS DEPARTMENT, JANUARY 2001. Cullars is holding one bound volume of the *Neuland*. UIC has the only collection of this Danube Swabian newspaper anywhere in the United States. (Photograph courtesy of Raymond Lohne.)

EMILY FRANCONA, WITH SENATOR DAN COATS (R-IN), MARCH 1998. Emily's family is of Transylvanian-Saxon ancestry. She finished her military career as an Air Force intelligence officer and then became a professional staff member on the U.S. Senate Select Committee on Intelligence. Her help in my research has become invaluable. (Photograph courtesy of Emily Francona.)

ANITA BUJAK, a Danube Swabian friend whose help with obscure research has been phenomenal. (Photograph courtesy of Anita Bujak.)

ALFRED MAURICE DE ZAYAS AND RAYMOND LOHNE, November 17, 2000, DUSQUESNE UNIVERSITY, CONFERENCE ON ETHNIC CLEANSING IN TWENTIETH-CENTURY EUROPE. (Photograph courtesy of Raymond Lohne.)

RAYMOND LOHNE AND PATRICK CATEL, LEFT, ORGANIZATION OF AMERICAN HISTORIANS ANNUAL CONFERENCE, ST. LOUIS, MO, APRIL 2000. Patrick edited my first *German Chicago* book. (Photograph courtesy of Raymond Lohne.)

CHRISTINA COTTINI, CHICAGO ARCADIA OFFICE, JANUARY 2001. Christina edited this book, for which I humbly thank her. (Photograph courtesy of Raymond Lohne.)

RAYMOND LOHNE, BARNES AND NOBLE, SQUIRREL HILL, PITTSBURGH, PA, NOVEMBER 15, 2000. Pictured, from left to right, are Dr. Hunt Tooley, Dr. Marianne Bouvier, Dr. Charles M. Barber, Dr. Agnes Vardy, author, Dr. Steven Vardy, and Elsa Walter at a collective book signing event, prior to the Conference on Ethnic Cleansing in Twentieth-Century Europe, held at Duquesne University. (Photograph courtesy of Raymond Lohne.)

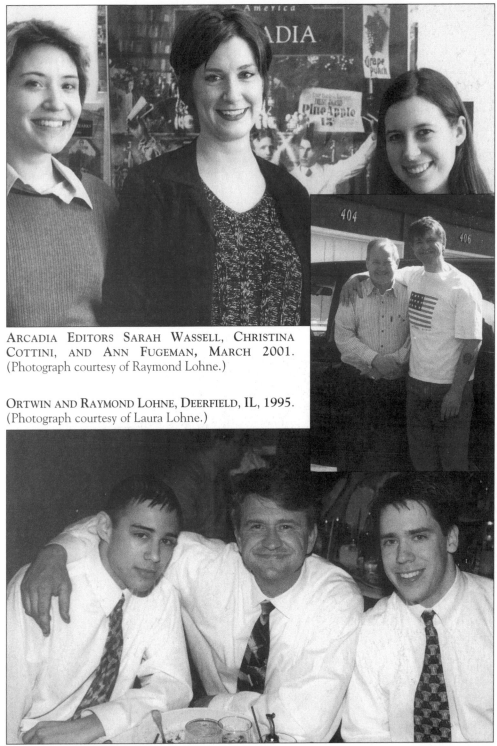

ARCADIA EDITORS SARAH WASSELL, CHRISTINA COTTINI, AND ANN FUGEMAN, MARCH 2001. (Photograph courtesy of Raymond Lohne.)

ORTWIN AND RAYMOND LOHNE, DEERFIELD, IL, 1995. (Photograph courtesy of Laura Lohne.)

JASON DAVID GARCIA, RAYMOND LOHNE, AND JOSHUA MILLER. (Photograph courtesy of Francesco Arena Photography, Northbrook, IL.)

RAYMOND LOHNE AND TYRONE ANDERSON, 1997. The author would like to acknowledge Joseph and Gloria Giralamo, Welton, Diomina, and Natalia Raelynn Wright—my new *bella bambina*. (Photograph courtesy Francesco Arena Photography.)

The author would like to correct an oversight by acknowledging Walter, Judy, and Colleen Smith, as well as the entire Giralamo family, especially Joseph and Gloria Giralamo. The author would also like to acknowledge Chris and Linda Marder.

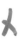